Seasons of Sacred Celebration

Seasons of Sacred Celebration

FLOWERS AND POETRY FROM AN IMPERIAL CONVENT

神まつる季節 尼門跡よりの花と和歌

Contributors: *Kasanoin Jikun*
Barbara Ruch
Sadako Ohki
Herschel Miller
General Editor: *Amy V. Heinrich*

INSTITUTE FOR MEDIEVAL JAPANESE STUDIES · FLOATING WORLD EDITIONS

First Floating World edition, 2006

Published jointly by the Institute for Medieval Studies, 509 Kent Hall, Columbia University, New York, NY 10027, and Floating World Editions, 26 Jack Corner Road, Warren, CT 06777.

Library of Congress Cataloging-in-Publication Data
 Seasons of sacred celebration / general editor, Amy V. Heinrich; contributors, Kasanoin Jikun . . . [et. al.]. —1st ed.
 p. cm.
 ISBN 01-891640-35-6
 1. Seasons in art. 2. Painting, Zen—Japan—Kyoto. 3. Calligraphy, Zen—Japan—Kyoto. 4. Japanese poetry—Illustrations. 5. Daishoji (Kyoto, Japan)—Art collections. 6. Painting—Private collections—Japan—Kyoto. I. Heinrich, Amy Vladek. II. Kasanoin Jikun.
ND1457.J325D357 1998
745.6'1'0952—dc21 98-36432
 CIP

Contents

Acknowledgments

謝辞

I n addition to those whose names appear in this book, the following individuals and institutions cooperated with the Institute for Medieval Japanese Studies in helping to make this publication possible. We extend to them our profound thanks.

この本に名前が載っている人々の他に、下記の方々に感謝の辞を述べたいと思います。皆さん快く中世日本研究所に協力してくださり、この出版を可能にして下さいました。心から感謝致します。

Tammy ALLEN, *Institute for Medieval Japanese Studies*
タミー・アレン、中世日本研究所

Keiko U. CHEVRAY, *Columbia University*
シェヴレー慧子、コロンビア大学

CHINO Kaori, *Gakushūin University*
千野香織、学習院大学

Annie CHU, *Institute for Medieval Japanese Studies*
アニー・チュー、中世日本研究所

Barbara FORD, *Metropolitan Museum of Art*
バーバラ・フォード、ニューヨークメトロポリタン美術館

FUKUDA Chizuru, *National Institute of Japanese History*
福田千鶴、国文学研究史料館

FUKUMORI Naomi, *Columbia University*
福森尚美、コロンビア大学

Maribeth GRAYBILL, *Swarthmore College*
メアリーベス・グレービル、スワースモア大学

KANAZAWA Tōun, *Daishōji Monzeki*
金澤東雲、大聖寺門跡

KAWAHIRA Hitoshi, *Atomi Gakuen Women's College*
川平ひとし、跡見学園女子大学

Elizabeth LILLEHOJ, *DePaul University*
エリザベス・リレホイ、デュポール大学

MAEDA Toshiko, *Kyoto Bunkyō Junior College*
前田訣子、京都文教短期大学

MATSUNO Yōichi, *National Institute of Japanese Literature*
松野陽一、国文学研究資料館

Jamie NEWHARD, *Columbia University*
ジェイミー・ニューハード、コロンビア大学

NISHIMURA Michiko, *Daishōji Monzeki*
西村道子、大聖寺門跡

Noelle O'CONNER, *Mary and Jackson Burke Foundation*
ノエル・オコナー、メアリー・アンド・ジャクソン・バーク財団

Shimizu Katsumi, *Shimizu Kōgeisha, Ltd.*
清水克実、（株）清水光芸社

Roberta Strippoli, *Institute for Medieval Japanese Studies*
ロベルタ・ストリッポリ、中世日本研究所

The Tides Foundation
タイズ財団

Stephanie Wada, *Mary and Jackson Burke Foundation*
ステファニー・ワダ、メアリー・アンド・ジャクソン・バーク財団

Yoshihara Kazue, *Independent artist, Kyoto*
吉原和恵、京都、個人美術家

For the 2006 First Floating World edition, we extend further thanks to:

Miho Walsh, *Institute for Medieval Japanese Studies*
ウォルシュ美穂、中世日本研究所

Ken Aoki, *Institute for Medieval Japanese Studies*
青木健、中世日本研究所

Greetings to the Readers

I am especially happy to welcome this first-time publication of one of the treasures we have carefully preserved over the centuries here at Daishōji Convent on this occasion which commemorates, on the other side of the world in New York, the 700th memorial anniversary of Zen Abbess Mugai Nyodai, the founder of our spiritual lineage.

I rejoice that the flowers of our beautiful *shikishi* and *tanzaku* poetry cards that have lain dormant in our storehouse for hundreds of years have come into full bloom in book form and that we can now share these extraordinary works with others, not only in Japan, but also around the world.

Kasanoin Jikun
Twenty-seventh generation Abbess
Daishōji Imperial Convent, Kyoto
November 1998

ご挨拶

このたび、大聖寺で私どもが永年にわたって大切に守ってまいりました所蔵品の一部が、この寺の開山であられます無外如大禅尼の700年遠忌を、はるか離れたニューヨークという異国の地で執り行わせていただくにあたりまして、はじめて出版されるようになりましたことは、私のこのうえもない喜びでございます。

　何百年にもわたって私どもの蔵に眠っておりました、美しい花の色紙と短冊がこのように本の形で花開き、日本の方々ばかりでなく、海外の皆様とも、この素晴らしさを分かち合えることができ、大変嬉しく存じます。

花山院慈薫

大聖寺門跡

第二十七世門主

平成十年十一月吉日

Foreword

The works introduced in this small book belong to the Imperial Convent Daishōji in Kyoto. They are being made public for the first time with the permission of the present twenty-seventh generation head of the convent, Abbess Kasanoin Jikun, on the occasion of the 700th memorial anniversary of the thirteenth-century Zen Abbess, Mugai Nyodai (1223–1298). Several interesting historical circumstances have converged to bring about the publication of this book, and I would like here briefly to share this background with the reader.

One day some years ago, when looking through a book about medieval Japanese sculpture, I encountered, quite by chance, a photograph of the extraordinarily lifelike thirteenth-century wooden portrait-statue of Abbess Mugai Nyodai. It was, without question, a revelatory encounter that changed the course of my scholarly life. The discovery of her existence made me realize for the first time that the world of Japanese religious history had a vast female side that had been totally ignored. I learned that when Abbess Mugai Nyodai, in her fifties, became a Buddhist nun, she was determined to study Rinzai Zen, the then newly-imported, cutting edge of continental Buddhism. She became the disciple of the Chinese monk Wu-hsüeh Tsu-yüan (1226–1286, known in Japan as Mugaku Sogen), who had recently come to Japan. Eventually he recognized her as heir to his teaching, and she became the first female Rinzai Zen master in Japan. She then went on to found the great temple-convent Keiaiji in Kyoto, which became the highest-ranking convent in the Five Mountain Convent Association, a powerful medieval network of Zen institutions for women.

To my astonishment I discovered that no scholar had ever studied this vast institution of powerful religious women, the history of which extended over many centuries. Keiaiji itself was destroyed in the civil wars of the late middle ages, but its spiritual flame was kept alive by its network of sub-

temples and by nuns in other convents as well. Most prominent among those convents still active today that revere Abbess Mugai Nyodai as their spiritual founder are the Rinzai Zen Imperial Convents Daishōji, Hōkyōji, and Hōjiin.

About a dozen imperial convents, or *ama monzeki jiin*, of various sects are still in operation today. They remain one of Japan's greatest cultural treasures, and yet they are barely known by scholars, to say nothing of the general public. Imperial convents are those convents where imperial women took the tonsure and resided as abbesses and nuns. While being places of spiritual discipline and worship, they were, equally, small aristocratic courts where the language of imperial circles was maintained and the cultural pleasures of poetry, calligraphy, and other traditional occupations of court women continued to be practiced. Entering a convent meant abandoning secular domestic married life, but it did not mean abandoning the cultural achievements that these noble women had attained. They brought with them to the convent, as if a dowry to a marriage, all manner of furnishings, libraries of books, secular and sacred scrolls, paintings, screens, lacquerware, utensils for the spiritual disciplines of tea and flower arrangement, and multitudinous other works of art. Once a woman took the tonsure, her magnificent secular robes remained treasures of the convent. If she had entered as a child, her exquisite toys and dolls, likewise, were treated with great care and preserved.

Over the centuries, the daily life of each imperial convent was recorded on paper. Its accounts, records of sale and purchase of land, the letters and diaries of abbesses, and directives from the imperial court were carefully retained in its storerooms. In short, these convents are today like small, locked jewel boxes filled with the pearls and precious stones of historic data, somehow forgotten, waiting to be rediscovered. Due to the ravages of time and to the enforced separation of the imperial house from Buddhism during the Meiji Restoration in the late nineteenth century, very few imperial convents remain today. The women now who have decided to become nuns and devote themselves to life careers in the imperial convents that have survived are vital spiritual and cultural guardians of one of the most extraordinary of institutions in Japanese history.

Daishōji is the highest ranking of the imperial convents in Kyoto today. Built originally in the fourteenth century, it considers the high-ranking court lady, Hino Senshi, to be the inspiring agent behind its founding. In 1338, Senshi was selected to raise and educate the newborn baby who would one day reign as Emperor Gokōgon of the Northern Court in Kyoto. A woman of outstanding character, she was greatly revered in the Shogunal court as well, especially by Shogun Ashikaga Yoshimitsu (1358–1408). At Emperor Gokōgon's death, Senshi became a nun, and Yoshimitsu invited her to take up residence within the grounds of his own palatial estate known as *Hana no gosho*, or the Flower Court. She lived there as a nun until her death in 1382, whereupon she received the posthumous Zen Buddhist name Daishōji Den Musō Jōen Zenni. The temple convent that Shogun Yoshimitsu created in her honor bore the name Daishōji, which was part of her posthumous name. Down through the ages, after Senshi's death, until the Meiji government enforced the exclusive practice of Shinto on the imperial household and forbade imperial princesses from embracing Buddhism, nearly all the abbesses of Daishōji were imperial daughters. Nonetheless, near the entrance gate to Daishōji Imperial Convent today stands a large natural rock inscribed with the words *Hana no gosho*, a relic of the convent's past origins and close association with the Shogun's Flower Court as well.

Unlike most of the famed monastery-temples for monks in Kyoto today, the imperial convents are not open to the public except on very rare occasions. We are deeply grateful, therefore, for the privilege extended to us that has allowed us to visit Daishōji, Hōkyōji, and their sister convents where the Institute for Medieval Japanese Studies has begun to examine the great store of records of their past and view the treasures of Japanese cultural history related to the generations of powerful women who became nuns there. It is now our hope that the Institute will be able to help the world outside these convents, both in Japan and abroad, to appreciate the important and fascinating historical and cultural role played over the centuries by the women of these institutions.

I am deeply indebted to Abbess Kasanoin Jikun, who first allowed me to enter Daishōji and pursue my search, first for traces of the legacy started by

the thirteenth-century Zen Abbess Mugai Nyodai, and then to bring other associates to pursue the lost history of Japan's imperial convents. With remarkable spiritual energy and profound cultural knowledge Abbess Kasanoin has done more than show us her material treasures; she has patiently revealed how to look at, see, and feel the inner spirit of Daishōji's treasures.

It was about three years ago during my third visit to Daishōji Imperial Convent that the extraordinary works of calligraphy, painting, and poetry published here for the first time were brought out for me to see. These *shikishi* poetry cards and *tanzaku* poetry slips made of delicate gold-dusted papers seem to glow with a burnished inner light. One is most astounded, however, to see each one wreathed with blooms and leaves of a different seasonal flower, tree, bush, or vine, which luxuriate out beyond the edges of its normal borders in a manner extremely rare in the history of the shikishi and tanzaku genres. The garlands never look like cut flowers meant merely to ornament. Rather, each plant appears as if growing in, out of, and around the paper cards—embracing them. Despite the overall similarity of painting design in each piece, and their uniformly subdued, quiet elegance and refinement, one nonetheless can feel the heavy weight, and yet the fragility, of the wisteria clusters on one, and sense on another the light breeze that disturbs the dandelions and violets.

Each card bears the hand-brushed calligraphy of a different member of the late-seventeenth-century nobility—each as unique as a finger print. Though convent records identify the calligraphers, the provenance of these works remains unknown. We do not know how or why they were made or what person or event, if any, they commemorate. Nonetheless I cannot help but feel the powerful presence of the only woman represented here, Princess Tsuneko, daughter of Emperor Gomizuno'o (1596–1680). She remained devoted to her father throughout her life, and there is something about these two series of works that seems to reflect the respect and affection she and his associates, and then later his grandchildren, felt for this man who was not only emperor, but who was one of the cultural leaders of his time as well. Princess Tsuneko's position as calligrapher of the second shikishi in the series of ten suggests to me that she might even be the originator of the set and that she deliberately and graciously yielded the hon-

ored place of calligrapher of the first shikishi to another, in this case, Tonsured Prince Tamehito of Imperial Temple Kajii.

The poems were selected from one or another text in Japan's classical poetic canon, immortalized in many cases by imperial compendium in an earlier age. There are songs that seem to be addressed to a flower, or to a season, or to a place, to an unnamed monarch, and ultimately in a certain way to the land of Japan itself. Painting, poetry and brushwork mark Japan's seasons. Time is marked by a blossoming, each flower and tree to its own time or season. Time immemorial, the seasons pass and are renewed, and thus are timeless.

It is wholly fitting, therefore, that these works, which celebrate, over the centuries, the timelessness of the ever-changing seasons of human life, are now published as part of this year's 700th memorial commemoration of Abbess Mugai Nyodai, the founder of the Rinzai Zen spiritual lineage of Daishōji Imperial Convent. The spiritual seeds planted by Abbess Mugai Nyodai in the thirteenth century, too, bloom fresh to every new generation and are as timeless as these flowers, each to its own eternal season.

<div align="right">

Barbara Ruch
Institute for Medieval Japanese Studies
Columbia University
November 1998

</div>

はじめに

　この小冊子で紹介された作品は、京都の大聖寺門跡が所有するものである。現御門主第二十七世花山院慈薫尼公の許可を得て、無外如大禅尼（1223–1298）の700年遠忌の記念行事の一環として今回はじめて本書のようなかたちで公刊されるのであるが、こうなった背後にはそれなりの理由がある。いくつかの歴史上の興味あるエピソードを紹介しながら、以下に、出版の経緯を簡単に説明してみたいと思う。

　数年前のある日、中世の彫刻に関する書物を読んでいたとき、偶然にも、十三世紀に生きた無外如大禅尼の素晴らしい等身大の木製彫刻の写真が私の目にとまった。それはまさしく運命的な出会いと呼ぶべきもので、その後の私の学問に対する姿勢を変えさせるような経験となった。つまり、無外如大との出会いによって私は、日本の宗教史のなかでいままでまったく無視されてきた女性が大きな役割を演じた可能性にはじめて気づいたのであった。調べてみると、彼女は、五十代になってから出家し、当時、中国大陸から輸入されたばかりの最先端の仏教であった臨済禅を学ぶために、中国から招かれ来日していた僧侶、無学祖元（1226–1286）の弟子となり、やがて法嗣となった。日本最初の女性の禅僧といわれている彼女は、その後、京都で尼寺院、景愛寺を興したが、この景愛寺はのちに、尼僧のための強力な連合体として作られた尼寺五山の最高位を占めるようになった。

　この幾世紀にもわたって続いてきた尼寺五山がいまだに学問的に研究されていないのは、驚くべきことである。その後、景愛寺は、中世後期に何度も起こった内戦によって焼け落ちてしまったが、その精神的な火は、景愛寺の塔頭等によって守られ、受け継がれていった。今日、無外如大禅尼を自分たちの精神的な開山とする、臨済禅宗の尼門跡寺院のなかでは大聖寺、宝鏡寺、宝慈院等がよく知られている。

　これ以外にも、いろいろな宗派の尼門跡寺院が活動しており、その数は十指に
あまる。これらの尼門跡寺院は、日本文化のなかのもっとも素晴らしい至宝の一
つであるのに、ほとんどの人が知らないのが現状である。尼門跡寺院とは、かつ
て皇女が出家した尼寺を指し、一方では精神的な修行を実践し祈りを捧げる場
であったが、他方では小規模の宮廷であり、そこでは宮廷言葉が使われ、出家す
る以前にたしなんでいた和歌や書、その他の文化的な活動も引き続き行われた。
尼寺に入ったのであるから、世俗的な結婚生活を捨てたのであるが、これらの身
分のある女性たちはそれまでに習得した趣味の世界は捨てたわけではなかっ
た。彼女たちは、まるで嫁入り道具を持参するかのように身の回りの品一切、書
物や巻物やお経、絵画、屏風、漆器、茶道や華道の道具一切、その他あらゆる美
術品を尼寺に持って行った。身分のある女性が出家したのち、豪華な着物類は
もちろんであるが、もしそれが幼少の頃だったら、贅を尽くして作られた玩具や人
形類も尼寺の宝物として大事に保存された。何百年にもわたって、尼寺の日常
生活は記録され、寺の収入や支出、土地の売買、尼僧たちの手紙や日記類、宮
廷からのお達しなどが倉庫に大切に保管されてきた。つまり、これらの尼寺は、
いわば真珠や宝石のいっぱい詰まった宝の小箱と同じであり、鍵をかけたまま
忘れられ、再発見されることを待っている歴史資料の宝庫であるといえるだろう。

　歴史の荒波にもまれ、また明治維新の時に起こった神仏分離によって宮廷か
ら仏教が追いやられたために、今日、少ない数の尼門跡しか残っていない。しか
し、こうした逆境にもかかわらず、生き残った尼寺もあり、そうしたところで尼僧
となり、一生を捧げる女性たちも存在する。彼女たちは、日本の歴史のなかの精
神的で文化的な伝統の非常に重要な守り主でもある。

　今日、京都の尼門跡のなかで最高位にあり、日野宣子を開基とする大聖寺は、
十四世紀に建てられた。1338年、公家の娘であった宣子は、のちに京都の北朝
の後光厳天皇となった、御幼少の世話と教育を任された。宣子は、第三代将軍の
足利義満からも敬慕されたくらいの、素晴らしい人物であった。後光厳天皇の死
後、宣子は出家し、岳松一品禅尼となったが、それを機に義満は、彼女を花の御
所と呼ばれた将軍家の邸宅内に招いて住まわせた。宣子は、死ぬまで花の御所

内に住み、1382年に亡くなったとき、大聖寺殿無相定円禅尼が諡られた。宣子の死後、義満は、彼女を偲び、尼寺院を創建し、その法名の一部を取って大聖寺と名付けた。明治維新以降、神道が正式に国家宗教となり、宮中における仏教の影響が小さくなってしまうまで、大聖寺の門主はほとんどすべて天皇の皇女であった。にもかかわらず、現在、大聖寺の門の脇にある大きな天然の石碑には「花の御所」と刻まれており、寺の由来と将軍家との浅からぬ縁を思い起こさせる。

今日、京都の多くの有名な男性の寺院と違い、尼門跡寺院は、年にきわめて限られた数の特別な行事を除いて一般に公開されていない。したがって、大聖寺や宝鏡寺などに出入りを許され膨大の量の過去の記録を少しづつ調べたり、影響力をもった多くの尼僧たちに関する文化史上の宝物を見たりできることは有り難いことでもある。私たち中世日本研究所の願いは、大聖寺やその他の尼門跡寺院が幾世紀にもわたって演じてきた素晴らしい、そして重要な歴史的・文化的役割を世界に紹介し、理解されるように努力することである。

大聖寺への出入りを許可され、まず無外如大禅尼にまつわる史料を、そして次に尼門跡寺院の失われた歴史に関する調査を許可して下さった現御門主第二十七世花山院慈薫尼公に対して深く感謝の意を表したい。門跡様の強靭な精神力と日本文化に関する深い知識のおかげで私は大聖寺の宝物の本当の見方と意義を教わったように思う。

今回、本書に紹介した作品に私がはじめて出会ったのは、三年前に大聖寺にお参りした際のことであった。確か、その時が三度目だったと記憶しているが、素晴らしい色紙と短冊が私の前に並べられた。金粉が微妙にちりばめられた、十枚の色紙と八枚の短冊には、書と絵と和歌が織りなす不思議な世界が内なる光を放ちながら輝いているように思えた。

本当に驚いたことに、これら一枚一枚は、その境界の縁からはみ出し繁茂する、四季の花、木、蔦によって包まれているのである。これは、色紙・短冊の歴史から見て大変に珍しい。これらの花輪は、単に装飾のために添えられた切り花のような存在というより、むしろ、まるで色紙・短冊から生えているように、出たり入ったりしながら、それらを包み込んでいるような印象を与えている。全般的な

絵画デザインは、それぞれ互いによく似ており、一様に抑制され、優雅におとなしく、洗練されている。それにもかかわらず、たとえば、ある短冊では藤の花の重さと、同時に脆さも感じることができるし、また別の色紙ではたんぽぽとすみれを揺り動かす微風を感じる。

　色紙・短冊の書は、17世紀後期の皇族と公家の手になるもので、それぞれの書家の名前はお寺の記録からわかっており、まるで指紋のように一つ一つ独特である。ところが、これらの作品の出所となると、まったくわかっていない。いったい、どういうふうにして、そして、なんのために作られたのか、あるいは、ある特定の人とか出来事を祝うためだったのか、われわれは知らないのである。とはいうものの、書家のなかの唯一の女性として常子内親王の存在を強く感じる。

　後水尾天皇（1596–1680）の娘であった彼女は、生涯を通じて父親と深い信頼関係で結ばれていた。これら一連の作品のなかには、天皇であると同時に、当時の文化的指導者の一人でもあった後水尾天皇に対する、彼女や、父の関係者や、さらにのちには孫たちの尊敬と愛情を感じさせる何かがあるように思われる。彼女は十枚の色紙セットの一番手の書家としてではなく、二番手の書家として登場しているが、一番手の書家としての名誉を梶井一品為仁法親王にゆずったことも想像できるので、ひょっとすると、彼女自身がこの色紙セットの発案者だった可能性も否定できないように思える。

　一方、和歌は、古くから愛誦されてきた日本の古典である勅撰集あるいは私家集から選ばれており、各々の歌は、ある特定の花や四季や場所や無名の日本の帝、そして究極的に日本に対して捧げられている。

　色紙・短冊のなかの絵画・和歌・書は、日本の四季を描いている。季節の移り変わりは、同じ種類の花が次々と開花して行くことによって表されたり、別の新しい種類の花が咲き出すことによっても、また草木の種類によっても表されている。季節は、昔から何度も何度も繰り返されてきたことであり、今後も従来通り同じことが繰り返されるであろうし、その意味では時間を超越しているといえる。

　大聖寺の開山である無外如大禅尼の700年遠忌の法要の一部として、絶えず変化するが、結局は何も変わらない人生の季節の永遠性を時代を越えて謳い上

げる、これらの作品を出版することは、それ故、何よりも相応しいことと思われる。13世紀に無外如大禅尼が蒔いた精神的な種も、色紙に描かれた花と同じように永遠であり、世代が新しくなるたびに新たに開花し、われわれを導いてくれる。

バーバラ・ルーシュ
コロンビア大学
中世日本研究所
平成十年十一月

Shikishi & Tanzaku

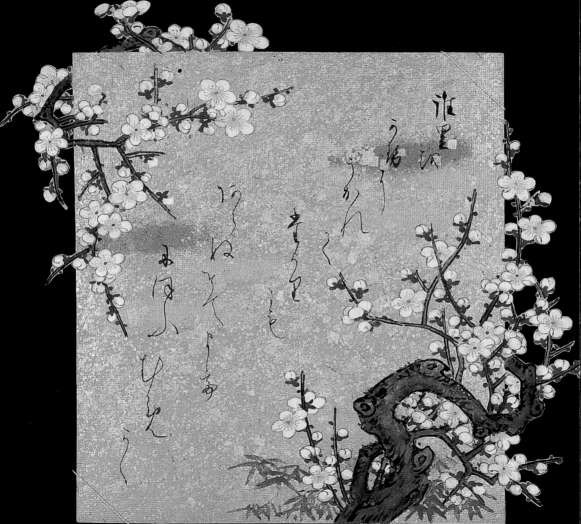

Where does it come from,
wafted on the breeze
even to such humble sleeves as these—
this fragrant scent of plum?

梶井一品為仁法親王筆

誰里を
越
可
勢
耳

かぜにうかれて
可
勢
耳
天
堂
里
毛

たよりにも
天
亭
丹
保

あらぬそでまで
阿
天
亭
丹
保
免
可

におふむめがか
阿
免
可

Tagasato wo
kaze ni ukarete
tayori ni mo
aranu sode made
niou ume ga ka

CALLIGRAPHER: Tonsured Prince Kajii Tamehito of the First Order (dates unknown).

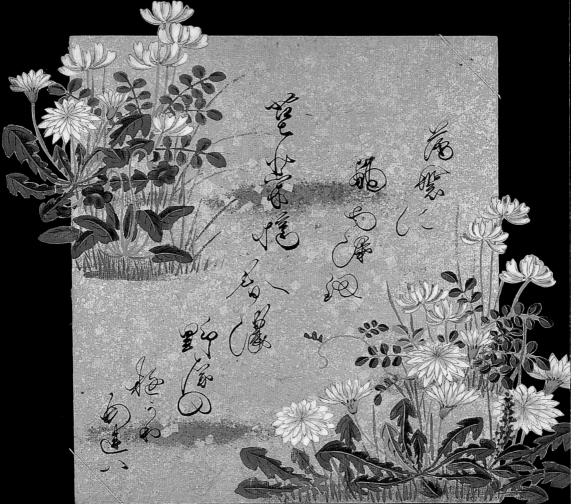

Can it be this gathering of violets
in a spring meadow
that has tinged my sleeves pale lavender?

後水尾天皇皇女級宮常子内親王筆

菫菜摘　春の野原の　ゆかりあれば

薄紫に　袖や染劍

Sumire tsumu
haru no nohara no
yukari areba
usumurasaki ni
sode ya some ken

CALLIGRAPHER: Princess Shinanomiya Tsuneko (1642–1702), daughter of Emperor Gomizuno'o.

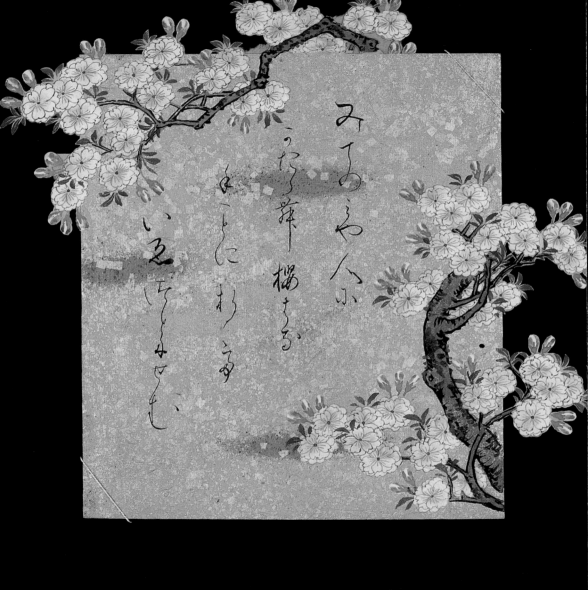

If all we do is gaze,
how will we ever tell them of
these cherry blossoms?
Let every hand break off a spray,
a souvenir in place of words.

花山院前内大臣定誠卿筆

みてのみや　人にかたらむ　桜ばな

手ごとに折て　いえづとにせむ

Mite nomi ya
hito ni kataran
sakurabana
te goto ni orite
iezuto ni sen

CALLIGRAPHER: Former Palace Minister Kasanoin Sadamasa (1640–1704).

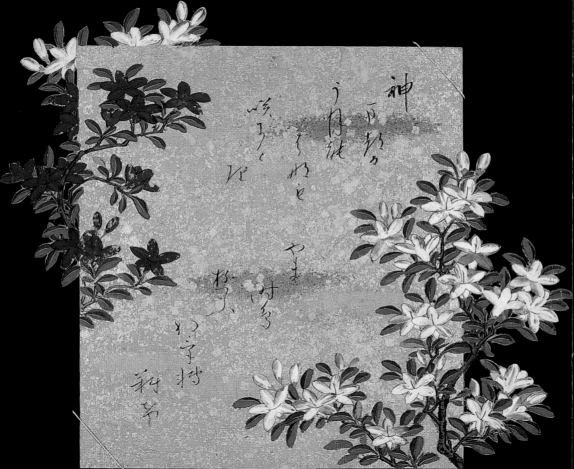

In sacred celebration of the gods,
the *unohana* blossoms
are in full bloom.
Come, mountain cuckoo,
sing us into summer's evenings!

Kami matsuru
uzuki no hana mo
sakinikeri
yamahototogisu
yūgakete nake

西洞院前大納言時成卿筆

神まつる　う月のはなも　咲にけり

やま時鳥　ゆふがけてなけ

CALLIGRAPHER: Former Major Counselor Nishinotōin Tokinari (1645–1724).

29

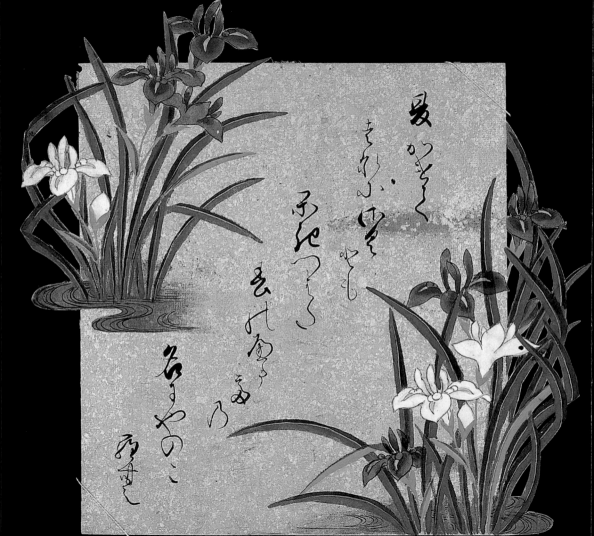

Though deep into the summer
You paint for us your blooms,
O row of iris,
will not your name go down
as the very flags that marked the end of spring?

東園権大納言基長卿筆

夏がけて　はなにさくとも　かきつばた　春のへだての　名にやのこらむ

遣天者那尔佐具登　閑起川者多

能遇多亭乃　尔羅無

Natsu gakete
hana ni saku tomo
kakitsubata
haru no hedate no
na ni ya nokoran

CALLIGRAPHER: Provisional Major Counselor Higashisono Motonaga (1675–1728).

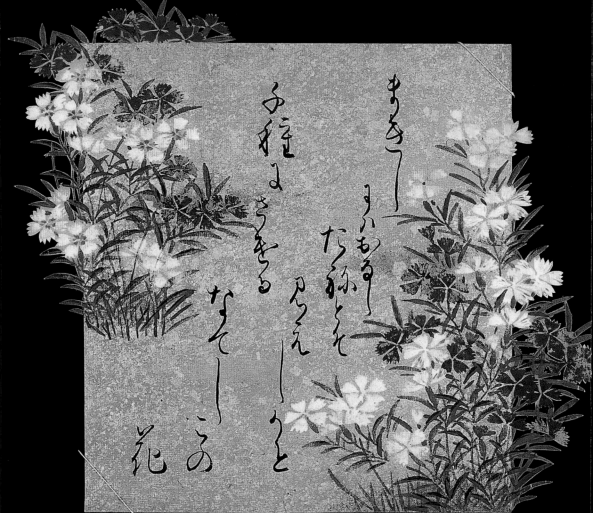

When sown,
the seeds all looked the same.
Yet now they bloom in a thousand shapes and hues,
the fringed pinks of summer.

伏見中務卿邦永親王筆

まきしには　おなじたねとぞ　見えしかど

千種にさける　なでしこの花

Makishi ni wa
onaji tane to zo
mieshikado
chigusa ni sakeru
nadeshiko no hana

CALLIGRAPHER: Minister of Central Affairs Prince Fushimi Kuninaga (1676–1726).

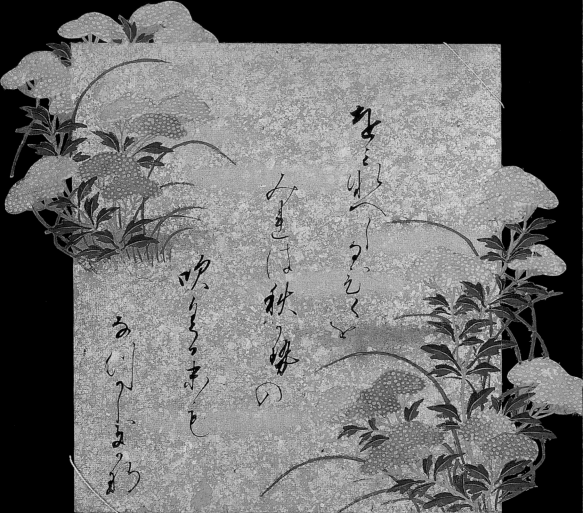

At the sight of the maidenflowers
bending in the autumn wind,
how I yearn for the place
from where it blows!

西三條中納言公福卿筆

越三那之名飛連
那之名飛可勢

吹くる末も
なつかしきかな

をみなへし
なびくをみれば
秋かぜの

具毛川可支可那

Ominaeshi
nabiku wo mireba
akikaze no
fuki kuru sue mo
natsukashiki kana

CALLIGRAPHER: Middle Counselor Nishisanjō Kimifuku (1697–1745).

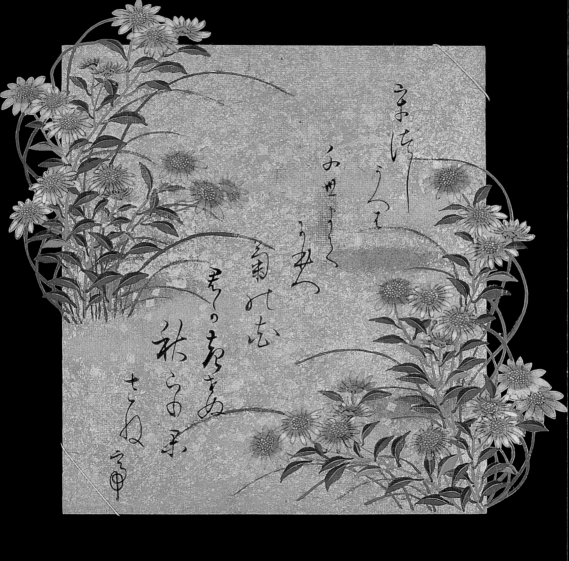

Transplanted,
let your splendor last a thousand generations,
chrysanthemum.
Never aging,
may Your Majesty greet
innumerable autumns.

花山院中納言常雅卿筆

うつしうへば　千世までにほへ　菊の花

君が老せぬ　秋をかさねて

宇
徒
者
天
尔
本
能
可
予
閑
亭

Utsushi ueba
chiyo made nioe
kiku no hana
kimi ga oisenu
aki wo kasanete

CALLIGRAPHER: Middle Counselor Kasanoin Tsunemasa (1700–1771).

37

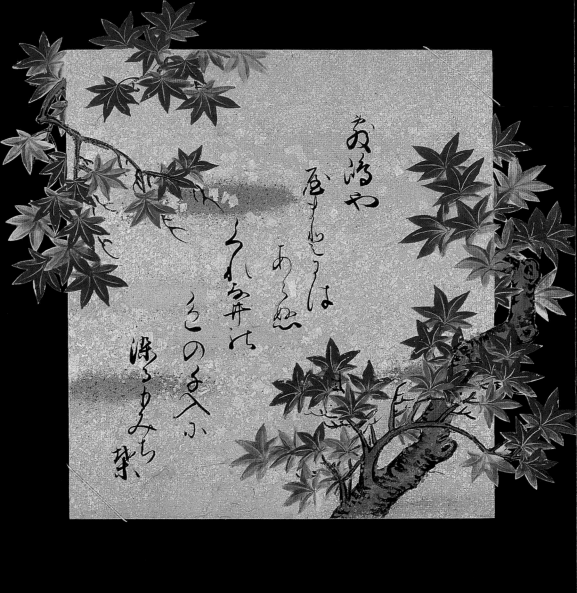

Dyed as if dipped a thousand times
in deepest crimson hitherto unseen
in all the islands of Japan,
these maple leaves.

色
の
千
入
に
染
る
も
み
ぢ
葉

敷
嶋
や
や
ま
と
に
は
あ
ら
ぬ
く
れ
な
い
の

有
栖
川
文
応
宮
筆

Shikishima ya
Yamato ni wa aranu
kurenai no
iro no chishio ni
somuru momijiba

CALLIGRAPHER: Prince Arisugawa Bunnō (dates unknown).

39

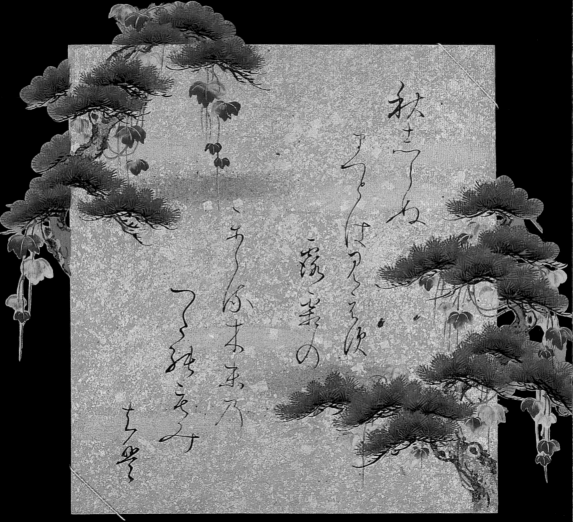

秋きぬと
めにはさやかに
見えねとも
風のおとにそ
おとろかれぬる

This hardly looks like
the pine which knows not autumn:
from its branchtips, rimed with frost,
hang brightly colored leaves of ivy.

醍醐大納言昭尹卿筆

秋しらぬ　まつとは見えず　露霜の

かゝる木末の　つたのもみぢば

Aki shiranu

matsu to wa miezu

tsuyujimo no

kakaru kozue no

tsuta no momijiba

CALLIGRAPHER: Major Counselor Daigo Akitada (1679–1756).

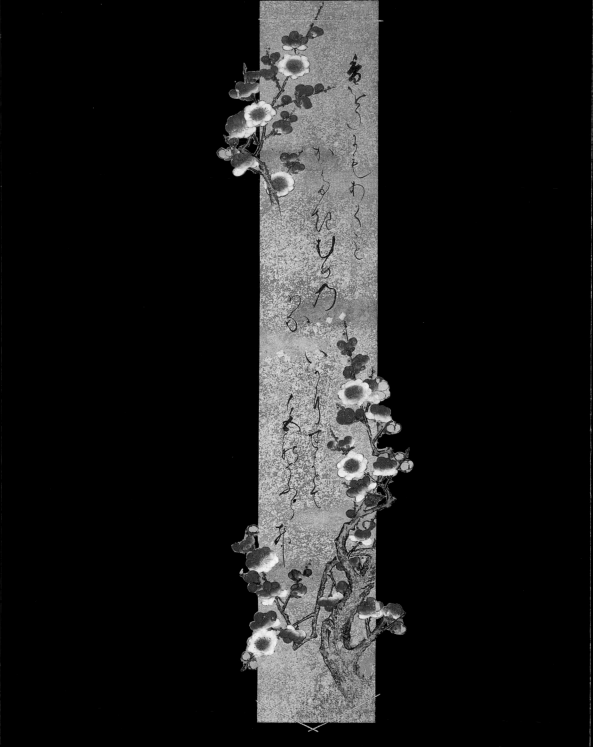

When your perfume alone
is never-failing delight,
O flowering plum,
what am I to do,
faced with your color, too?

實心繫院一品堯延親王筆

香をだにも　あくことがたき　むめのはな

多尒毛　　　多起　　　　　　乃八奈

いかにせよとて　色のそふらむ

可耳　　　　　　能舞

Ka wo dani mo
aku koto gataki
ume no hana
ikani seyo tote
iro no sou ran

CALLIGRAPHER: Prince Jisshinkei'en Gyōen of the First Order (1676–1718)

43

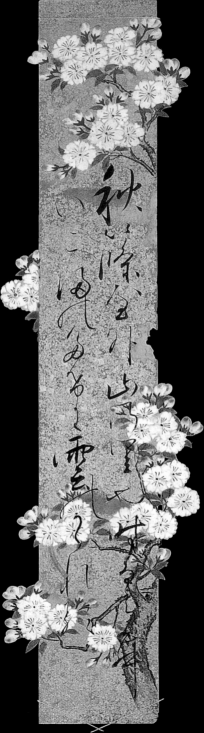

At that village nestled in the hills
of Akishino, famed for autumn bamboo-grass,
Already—can it be?—
Mount Ikoma bedecked in white, like clouds.

Akishino ya

toyama no sato ya

toki naran

Ikoma no take ni

kumo no kakareru

有栖川二品幸仁親王筆

秋篠や　外山の里や　時ならむ

屋
乃

奈
羅
舞

満
能
多
希
尓

能
可

類

いこまのたけに　雲のかゝれる

CALLIGRAPHER: Prince Arisugawa Yukihito of the Second Order (1656–1699).

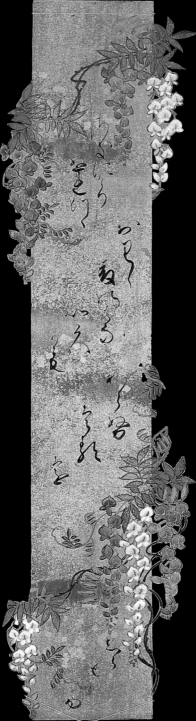

So they have bloomed!
I break off a spray of wisteria,
drenching myself,
and know that the days of spring are numbered.

Sakinikeri
nuretsutsu orishi
fuji no hana
ikuka mo aranu
haru wo shirasete

中院前内大臣通茂卿筆

佐支介

連川里

能者奈

さきにけり ぬれつゝおりし 藤のはな

以久可毛努盤類遠志亭

いくかもあらぬ はるをしらせて

CALLIGRAPHER: Former Palace Minister Nakanoin Michimochi (1631–1710).

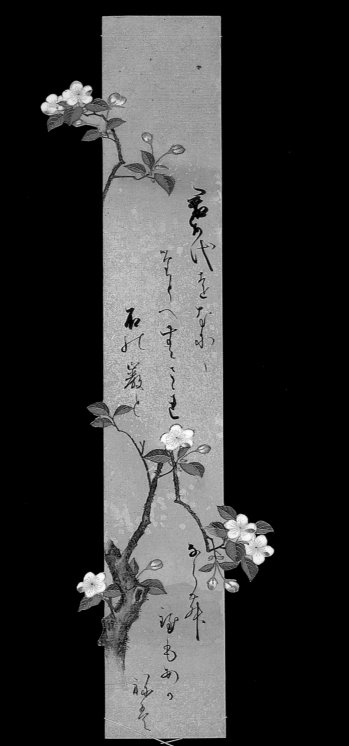

To what shall we compare Your Majesty's reign?—
when it will last till tiny pebbles
have into mighty boulders grown.

Kimigayo wo
nani ni tatoen
sazareishi no
iwao to naran
hodo mo akaneba

巌 君 冷
と が 泉
な 代 三
ら を 位
む 為
久
程 な 卿
も に 筆
あ ゝ
か た
ね と
ば へ
む
さ
ゞ
れ
石
の

CALLIGRAPHER: Lord Reizei Tamehisa of the Third Rank (1686–1741).

49

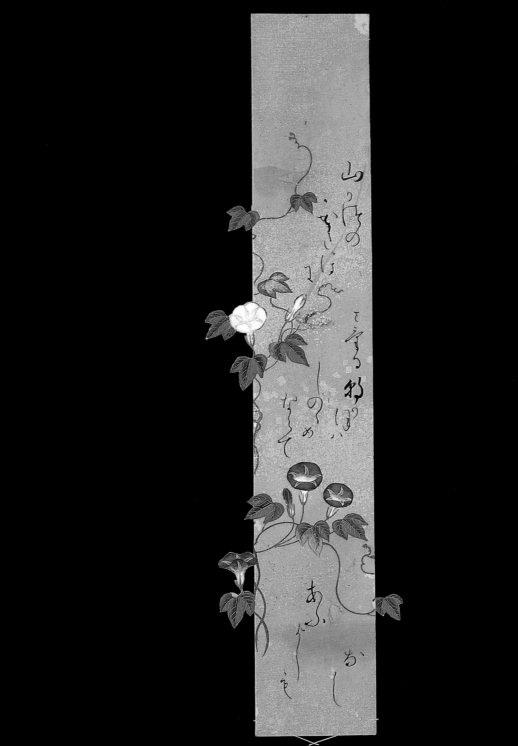

Only at the break of day
am I favored with a glimpse
of the morning glory
blooming on the fence
of a mountain hut.

Yamagatsu no
kakiho ni sakeru
asagao wa
shinonome narade
au yoshi mo nashi

園中納言基香卿筆

山がつの　かきほにさける　朝がほは
しのゝめならで　あふよしもなし

CALLIGRAPHER: Middle Counselor Sono Motoka (at court 1715–1745).

51

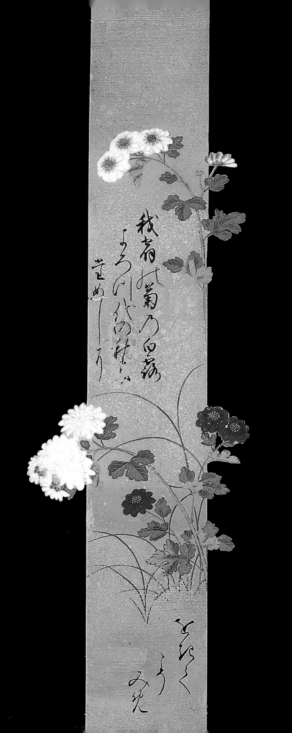

我宿ハ菊乃白露
まろ川代の社に
茎めしう

とくしく
もう
みえ

Upon the chrysanthemums
in our family's garden
as every autumn
for a thousand generations
may we see the bright dew form.

青蓮院二品尊祐法親王筆

我宿の　菊の白露　よろづ代の

秋のためしに　をきてこそみめ

Wagayado no
kiku no shiratsuyu
yorozuyo no
aki no tameshi ni
okite koso mime

CALLIGRAPHER: Tonsured Prince Shōren'in Son'yū of the Second Order (1698–1747 or 1751).

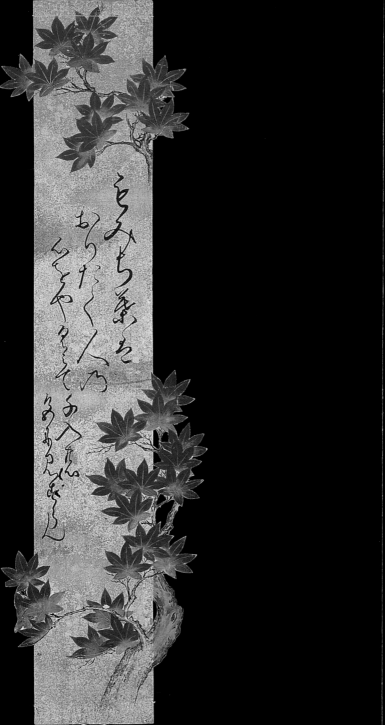

ともち葉の

むらたく人の

もとをやまをそ

もへ行らん

わかれなん

Could it be that the maple leaf
fathoms the heart of one who feeds the fire,
and so takes on this hue
as though dipped a thousand times in crimson dye?

伏見中務卿邦永親王筆

もみぢ葉は　おりたく人の　心をや

くみて千入の　色に見すらん

Momijiba wa
oritaku hito no
kokoro wo ya
kumite chishio no
iro no misu ran

CALLIGRAPHER: Minister of Central Affairs Prince Fushimi Kuninaga (1676–1726).

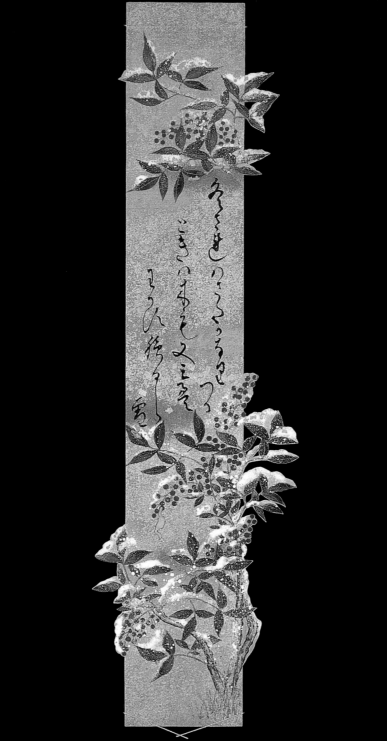

With winter's coming
we should clearly see
which trees are evergreen;
and yet I cannot tell yet which they are
under all this snow.

Fuyu sareba
sadaka naritsuru
tokiwagi mo
mada miewakazu
tsumoru shirayuki

七條宰相隆豊卿筆

冬されば　さだかなりつる　ときは木も

又みえわかず　積るしら雪

CALLIGRAPHER: Consultant Shichijō Takatoyo (at court 1670–1686).

57

The Flower Court Poetry Cards at Daishōji Convent

Sadako Ohki

Two sets of intriguing artistic works are preserved at Daishōji Imperial Convent in Kyoto, one in the *shikishi* format and the other in the *tanzaku* format. We have decided to name these sets the Flower Court (*Hana no gosho*) Poetry Cards not only because they depict flowers of the various seasons but because Daishōji Convent has roots that connect it both to the imperial court and to the *Hana no gosho* or Flower Court of Shogun Ashikaga Yoshimitsu.

In the history of Japanese art and poetry, both shikishi and tanzaku formats have played an important role. Shikishi are almost square in shape but slightly longer vertically than horizontally. Tanzaku, in contrast, are taller and more rectangular. The term shikishi literally means "colored paper." Often decorated with calligraphy, this colored paper, beginning in the Heian period, customarily adorned furnishings such as folding screens. Shikishi sizes vary because, over time, square-shaped pages of poetry have been removed from poetry albums, their bindings cut, to make independent works of art. When calligraphy began to be admired at tea ceremonies in the sixteenth century, certain shikishi were taken from albums and mounted on hanging scrolls so that viewers were able to appreciate them at the gatherings.

One of the oldest extant shikishi bearing calligraphy is "Ogura no shikishi" by Fujiwara Teika, dated 1235. Poets often composed *waka* on *kaishi*, thin paper carried in the bosom or sleeve of one's robe and used as a handkerchief or writing pad, rather than on shikishi. Only when the famous calligrapher Hon'ami Kōetsu (1558–1637) began writing calligraphy directly on prints designed by such artists as Tawaraya Sōtatsu (exact dates unknown but active ca. 1643) did shikishi emerge as a popular artistic form and a means of permanently recording calligraphy.

Tanzaku, the rectangular format, has been popularly used for poetry writing—first waka in the Kamakura period and later haiku—for much of Japan's literary history. Although the size of tanzaku vary, each piece in this

particular set measures approximately 36.4 by 11 centimeters from one edge to another, including the painted sections that extend beyond the border of the paper. Tanzaku, meaning "short strips," originally were made of wood or paper, and small pieces of twisted paper were used for divination purposes in early Japanese history. Some of the oldest examples of tanzaku bearing waka have religious significance. Written in 1344, these tanzaku are the product of a request by Ashikaga Tadayoshi (1306–1352) that his friends and subordinates compose waka in which each poem begins with one of the syllables that comprise the sentence *Namu Shakabutsu zenshin shari* (Shakyamuni Buddha's entire body is sacred bones).[1] During the Muromachi period, tanzaku gained popularity as poets began to use them as well as kaishi and shikishi at official poetry matches (*uta awase*). Then, beginning in the late fifteenth century, tanzaku became more elaborate when calligraphy garnished enticing gold and silver paintings and prints.

The Flower Court Poetry Cards are particularly intriguing not only because they display such courtly beauty, but also because they deviate from conventional ways of writing waka on shikishi and tanzaku. These works of art depart from standard practices in that they embody painting which, uniquely, extends beyond the borders of the card; they contain waka selected from both ancient imperial anthologies and private collections of waka ranging from the tenth through the sixteenth centuries, an unusual range; and they were produced by a group of relatively unknown calligraphers at court, including one daughter of Emperor Gomizuno'o (1596–1680).

Perhaps the most striking of these deviations are the beautiful seasonal floral motifs which protrude beyond the borders of each piece. Each of the shikishi measures approximately 19 by 21 centimeters across the outermost edges of the extended areas; the upper-right and the lower-left corners maintain standard ninety degree angles and remain free of floral decoration. In addition, each of the ten shikishi in the Flower Court Set bears paintings of seasonal flowers commonly found in Japanese poetry and artwork. However, these painted blossoms, unlike those of other shikishi, extend beyond the paper, rendering an unusual feeling of abundance. Similar to the shikishi, the flowers on the eight tall, rectangular tanzaku also protrude

beyond the edge; however, these extend from the middle three quarters of each piece and leave the four corners blank.

This effect of plentitude was created not by painting the flowers beyond the edge of the original paper, but by cutting the flowers from paper which had been coated with gold pigment and multiple colors of paint and which was larger than the finished products we view today. (See photograph at right of the back of Shikishi Ten.) The blossoms seem to have been cut with meticulous care, given that they include extremely thin autumn grasses highlighting chrysanthemums, long hanging ivy vines clinging to a cluster of green pine needles, and crimson maple leaves. One is astonished that such delicate work has been preserved in such excellent condition. Yet it is still possible that a few works may be missing from the original sets.

This unusual technique can be seen in only one other example in North America that I know: a set of six shikishi in the Mary Griggs Burke Collection mounted as an accordion-like album, "Six Poets from the *Shin kokin waka shū*." The set is smaller than the Daishōji set and emphasizes landscape rather than flower motifs. [2]

Historically, shikishi were usually mounted on screens, in albums, or on vertical hanging scrolls. The Flower Court Cards, however, are each secured with thread to a separate, larger piece of black cloth-covered cardboard. The thread runs across each of the two blank corners of the shikishi. When displayed, the shikishi are laid flat on a table or the floor. This method suggests that the paintings were not sturdy enough to have been displayed vertically. Alternately, they originally may have been viewed in a set of albums, as in the case of the material mentioned above. Like the shikishi, the tanzaku are mounted on larger cloth-covered cards and supported by two

threads which cross each other at the bottom and another thread which crosses the top of the tanzaku to hold it in place so that, in principle, they could have been hung vertically. In reality, however, this method does not support the work well enough for it to be hung safely.

None of the eighteen shikishi or tanzaku bears a signature or seal on its painted surface; only convent tradition provides authorship. Both a shikishi and a tanzaku have been ascribed to the same calligrapher, and thus seventeen, rather than eighteen, artists seem to have brushed the sets.

Considering the overall stylistic uniformity of format and flowers in both the shikishi and tanzaku sets, we can conjecture that the sets were produced simultaneously, or perhaps for the same specific occasion. (The waka have been translated here in light of this consideration, although we have not yet determined exactly what the occasion may have been.) However, the dates of the calligraphers (see Chronological Charts A and B) lead us to conclude that it would have been impossible for all the calligraphers to gather in one place, at one time, to produce the sets. In the case of the shikishi, for example, one calligrapher was only two years old in the year another died. And in the case of the tanzaku, one calligrapher was born in the year another died. It is possible that some dates may be inaccurate, perhaps attributable to the erroneous recording of calligraphers, and perhaps because sets such as these may have been created for multiple occasions, thus causing works from various sets to become disordered and even inadvertently mixed up with one another.

Formal rules on how to write a waka on a tanzaku are intricate; for example, about the top quarter should be used to record the topic of the poem; the waka should be written from right to left in two columns beneath the topic, followed by the signature of the author at the bottom left; and the second column should start one character lower than the first column if the topic had been omitted. That is, poets had to write their waka in two columns, leaving enough space for the signature at the end. If too many kana were used, there would not have been enough space left at the end to finish recording the poem because one Chinese character can replace multiple syllables; if too many Chinese characters were used, excess space may have remained.

These medieval rules of poetry writing were no longer strictly observed in the Edo period. Many waka were written in two columns, but sometimes topics were omitted, or long forewords were added. At the same time, artists began to add elaborate decoration to tanzaku and to write calligraphy on top of designs garnished with gold and silver foil, flakes, and dust. Kōetsu seems to have established the practice of writing calligraphy over ornamental painted or printed patterns of flowers, birds, and landscape, including cherry blossoms, *unohana* (Deutzia), pinks, chrysanthemums, pampas grass, cranes, and seashore with pine trees.

These shikishi and tanzaku contain neither topics nor calligraphers' signatures. The flower paintings, which themselves depict themes, replace the need for topics, and the lack of signatures indicates that, although the calligraphers wrote out the poems, they did not credit themselves as the original authors. In other words, the calligraphers brushed poems previously written by entirely separate authors. In light of this, it is clear that the sets were not created at the usual poetry composition parties.

In addition, none of the shikishi feature calligraphy superimposed on the painting. After the painting on the shikishi was completed, space was left for the calligrapher to brush his work. Among the eight tanzaku, superimposed calligraphy appears only in one work: on top of the sumptuous painting of cherry blossoms on the piece ascribed to Prince Arisugawa Yukihito (1656–1699). Among the eighteen cards, this piece most closely resembles the calligraphy-painting style begun by Kōetsu which was in vogue in the late seventeenth century, when these shikishi and tanzaku were most likely produced.

On the other hand, among published works, two pieces by Tosa Mitsuoki (1617–1691), then director of the Imperial Court Painting Bureau, closely resemble the Flower Court Poetry Cards. His pair of six-panel folding screens, depicting maple and cherry trees ornamented with hanging tanzaku, as well as his painting "Birds and Flowers of Spring and Autumn," seem quite similar to the Flower Court sets. Currently held at the Chicago Art Institute[3] and the Eisen Art Museum in Hyogo prefecture,[4] respectively, the screens were most likely painted between 1645 and 1678.

The similarities to the Flower Court Poetry Cards lie in the form of the maple leaves and the technique with which they were painted. The maple

leaves in Mitsuoki's works are not only shaped like some of those in the shikishi, but they also portray the same techniques of dropping green pigment into the centers of red leaves and outlining them with silver pigment to produce different shades. Both the painter of Tanzaku Seven of the Flower Court Poetry Cards and Mitsuoki seem to have drawn each leaf, often in gold, with precise and even lines from the center of a leaf to its tip. Their handling of this painting technique is formal but not stiff.

The poetry and painting themes of the Flower Court Poetry Cards include plum blossoms, violets, cherry blossoms, unohana, irises, wisteria, the flowering orange, morning glories, pinks, chrysanthemums, maiden-flowers, maples, the pine tree, and the snow-capped *nanten*, all of which are largely traditional themes. The herbal grasses that later became popular as painting themes, encouraged by the advance of the study of botany, were not included in these sets. Scientific accuracy is absent, but a graceful liveliness based on an observation of nature can be seen, for example, in the way the violets were painted among dandelions and *rengesō* (literally, "lotus grass") in Shikishi Two. The paintings concentrate on floral themes without the accompaniment of birds or landscape, and the Flower Court Poetry Cards do not seem to be associated with the established twelve-month theme of Fujiwara Teika's waka.[5]

Members of the Rinpa school, which became popular after gaining the support of privileged merchants, also focused on one theme in their paintings, but their design approach regarding plants leaned toward a new, bolder unconventional format that implicitly expressed narrative, rather than using the explicit narrative of poems. In contrast, the Flower Court Cards present a more conservative approach, employing an earlier painting technique and palette as well as the conventional narrative waka. Indeed, it is possible that members of the Tosa school, headed by Mitsuoki, produced the Flower Court Cards. Although the Tosa style may appear conservative, Mitsuoki was not merely following a dead tradition. On the contrary, he studied the naturalistic Chinese painting of the Sung and Yüan periods to establish his own courtly style. His style seems to have captured the taste of Japanese aristocrats of the mid- to late-seventeenth century who were no

longer in the limelight economically or culturally. Mitsuoki's work, which revitalized a courtly tradition, appealed to an aristocratic sense of nostalgia.

The Flower Court Cards appear refreshing in contrast to the rather grand, over-emphatic, and over-publicized Rinpa works and Kanō school screen paintings. The refined, gentle courtly beauty and careful treasuring of classical literature expressed so well in these cards encourages a new look at this somewhat marginalized art of the courtly tradition. Because the Flower Court Cards are unsigned and undated, we do not know exactly who painted them or when, but the elegance of the painting, as well as the sure handling of the brush, strongly supports the idea that they were painted by an artist like Mitsuoki or perhaps someone slightly later among the Tosa school artists. By the seventeenth century, the Tosa and the Kanō schools were no longer rivals, and the Kanō school in Kyoto received many commissions from Empress Tōfukumon-in. Throughout the history of Japanese art, however, the Tosa school was most popular in aristocratic circles, where it was patronized by the court.

Among the ten calligraphic hands of the shikishi, three styles can be clearly distinguished. The most distinctive style is that of the only piece produced by a woman calligrapher, Shikishi Two, by Princess Shinanomiya Tsuneko (1642–1702), a daughter of Emperor Gomizuno'o. Even after her marriage to Konoe Motohiro, she remained very close to her father; she was, in fact, the person beside the emperor's bedside when he died. Emperor Gomizuno'o had thirty-three children, and a number of his daughters became abbesses (see Chronological Chart C). Many died rather young, but Princess Tsuneko enjoyed a long life and frequently visited her father at his villa, the Shūgakuin, to spend days of leisure admiring residential architecture, visiting tea huts, boating in the Yokuryūchi Pond, and participating in tea ceremonies and banquets.[6]

Princess Tsuneko's calligraphy is very distinctive, with many circles, hooks, and wavy lines within a syllable or character. Her calligraphy was the most difficult to decipher among the eighteen pieces, not only because of her calligraphic style, but also because of the formatting, called *chirashigaki* or "scattered writing."

A poem written in chirashigaki is not written in the typical fashion from right to left; rather, in this particular case, the first line begins in the middle of the paper. From there, the poem moves to the left until reaching the far-left border, and then comes back to the far-right border, from which point it moves toward the left until it stops just before the center, where the first line began. During the medieval period lady attendants to emperors (*nyōbō*) developed this elaborate scattered writing style when they wrote letters for emperors. Many Heian calligraphers employed the scattered writing style when they composed poems, although women in particular took an interest in developing it, and calligraphy written in this format by emperors themselves are still extant as well. The poem in Shikishi Two, on the gathering of violets, is an excellent example of this scattered writing style.

Despite the difficulty in reading the Princess's handwriting, I am elated to find a woman's calligraphy so different from that of the men. I wonder if Princess Tsuneko proudly identified herself as a woman by exhibiting her unmistakable calligraphic style, as well as by formatting her calligraphy differently from the men's. Not many women calligraphers are included in major encyclopedias of Japanese calligraphy; for example, there are only forty-three out of more than 279 in the *Nihon shoseki taikan*.[7] Calligraphy brushed by women is one of the most understudied fields in Japanese art history. A traceable lineage of Princess Tsuneko's calligraphic style, however, provides some insight.

The lineage begins with a famous female calligrapher, Ono no Ozū (1568–1631?), who lived shortly before the time of Princess Tsuneko. Her name has been read as "Otsū," but recently, a document was found which recorded the reading of "Ozū." She was invited by Tokugawa Ieyasu to teach etiquette at his domain in Sunpu (present-day Shizuoka prefecture). Eventually she entered Osaka castle, and was entrusted by Hideyoshi's wife, Yodogimi, to teach etiquette and calligraphy to the women there.[8]

Ozū's calligraphic style is grand, fluent, and witty. Contrary to one's expectation that a woman's writing is small, delicate, and sensitive, she wrote large characters as well as small ones, always in swift, contiguous, and exaggerated lines. She excelled in drawing human figures outlined in several bold strokes; faces were drawn with sensitive brushwork following the

nise-e ("likeness" portrait) tradition. Her quick, strong, and energetic han-
dling of the brush foreshadows Princess Tsuneko's calligraphic style. Ozū's
style was very popular for approximately one hundred and fifty years
among ladies of high rank.[9] It seems that Ozū was a woman of vision who
effectively utilized her position in society, captured women's interest in cal-
ligraphy, and organized a productive teaching environment for them.

Princess Tsuneko's calligraphy style recalls the work of Ozū in her free-
spirited and swift handling of the brush, but other than this similarity,
Tsuneko's calligraphy does not closely resemble any styles I have studied.
It does not belong to the Shōren'in school founded by Prince Son'en in the
fourteenth century and often used to record poems on tanzaku. Nor does
it resemble the *Oie ryū*, or "House Style," which was derived from the
Shōren'in school, and gradually gained popularity in the seventeenth cen-
tury to become the dominant calligraphic style for textbooks and govern-
ment documents. The wavy, twirling lines of the Princess slightly resembles
the style developed by Shōkadō Shōjō (1584–1639), one of the three noted
calligraphers of the early- to mid-seventeenth century, but it is not close
enough to classify it within his school.

Considering the historical background of calligraphy in Japan, I can
think of two sources that might have influenced Princess Tsuneko's style.
The first is *ashide* calligraphy, an amalgamation of calligraphy and painting.
A landscape painting of the shore, for example, may conceal the letters and
characters of a waka poem within its scenery. The developed curvilinear
lines in Princess Tsuneko's calligraphy can be traced to the pictographic
influence of ashide. The second possible influence is *kaō*, an art of mono-
gram signatures comprised of many complicated brush lines, developed
during the medieval period. The intricacy of Princess Tsuneko's calli-
graphic style resembles the concealment of brush strokes found in kaō.
Despite these similarities, most important in considering her calligraphic
style is not to force it into the framework of the established schools of her
time, but to remain open, as art historians, to the possibility of finding a
regional and/or gender-defined style that is not yet known to us.

The calligraphic style of the second group of calligraphers who inscribed
the poems on Shikishi Five, "Irises," Shikishi Six, "Pinks," Shikishi Seven,

"Maidenflowers," and Shikishi Nine, "Maple," tends to feature wider brush strokes, which accentuate the surface plane, than those used by Princess Tsuneko. Most of the calligraphy in this second group is written from right to left with the columns positioned lower as the lines move to the left, and uses only the open space for calligraphy so as to avoid obscuring the painted flowers or leaves. Almost no other calligraphy by this group of courtiers has been published, and it is therefore impossible for me to verify their individual styles. It is clear, however, that their styles do not resemble those that prevail in the schools of Hon'ami Kōetsu, Shōkadō Shōjō, Karasumaru Mitsuhiro, or the House Style.

The third group consists of five shikishi, including Shikishi One, "Blossoming Plums," Shikishi Three, "Double Petaled Cherries," Shikishi Four, "Unohana," Shikishi Eight, "Chrysanthemums," and Shikishi Ten, "Pine with Ivy." Their lines tend to be much thinner than the rest, without much variation between thick and thin. Again, their calligraphic styles do not recall any fashionable ones of that time. The writing looks natural, in the sense of being close to the classical kana calligraphy of the Heian period represented by works attributed to Fujiwara Yukinari. We should remember that Konoe Iehiro (1667–1736), son of Princess Tsuneko, was skilled in the Yukinari style of classical calligraphy, although current Japanese scholarship on calligraphy does not give his work the recognition it deserves. To date, study of the new calligraphic style, which was taken from the courtly tradition and revived by the privileged merchant class, has been emphasized, while the aristocratic lineage of calligraphy in the seventeenth century and later has been dismissed as peripheral and uninteresting. Little is understood about what eventually happened to aristocrats' calligraphic styles during the Tokugawa period, but I believe an inkling of what was happening in those styles has now been made available to us in these Poetry Cards.

The eight tanzaku can also be divided into three subgroups by their calligraphic styles. As mentioned earlier, Tanzaku Two, "Cherry Blossoms," is the only work in which the calligraphy is inscribed over the painting. This waka is also the only one written in two clear columns in accordance with traditional waka writing in tanzaku format, although the cluster of white flowering cherry blossoms takes the place of the topic. The calligraphic style

is also different from the rest of the tanzaku: the size of each syllable or character is much larger than those of the other tanzaku, and so it seems that the calligrapher was not worried about writing on top of the painting. According to convent tradition, the calligrapher was Prince Arisugawa Yukihito, son of Emperor Gosai, and grandson of Emperor Gomizuno'o.

The waka written on this tanzaku is problematic because the poem as it is known in other sources is clearly unsuited to the gorgeous cherry blossom painting. Almost all of the other waka were identifiable, with the exception of Tanzaku Seven. The waka in Tanzaku Two is identifiable, but the third line of the poem as written on this tanzaku differs from the standard form of the poem, which is by Priest Saigyō, about a dreary autumn rain with a background of misty clouds over Mt. Ikoma in Nara. A detailed examination of the calligraphy, however, reveals a crucial change in the reading of the third line. (For details, see the notes on Tanzaku Two). Saigyō's waka reads, "Might the gentle rain be falling there?" (*shiguru ran*), while Prince Yukihito's calligraphy reads, "Already—can it be?—" (*toki naran*). The abbreviated calligraphic form of the Chinese character for "time" is followed by indistinct graphs or a graph that could either be read as the Chinese character for "rain" plus a kana syllable *ru*, or for the single syllable *na*. This small choice between the two possible readings has completely changed the meaning of the poem. Prince Yukihito may have made a copying error, or he may have intentionally created a different poem out of the classical verse by a deliberate misreading to make the poem into a scene of cherry blossoms. Yukihito's choice, unlike Saigyō's original, renders the poem appropriate for the painting. However, there is no way of knowing whether the choice made by Yukihito was intentional, or simply a copying mistake.

The second group of tanzaku consists of Tanzaku One, "Plum Blossoms with Red Center," Tanzaku Seven, "Crimson Maple," and Tanzaku Eight, "Snow-capped Nanten." They are distinguished not by their calligraphic style but by the use of space in their writing. These calligraphers wrote the waka within the central open space, and each possesses a distinct calligraphic style. Prince Fushimi Kuninaga, Minister of Central Affairs (1676–1726), is credited with having written the calligraphy for both the waka about maple trees on Tanzaku Seven and the poem about

pinks on Shikishi Six; the calligraphic styles of the two appear similar enough to ascribe them to the same person. His style is loose and relaxed in contrast to that of Tanzaku Eight by Consultant Shichijō Takatoyo (at court 1670–1686), which is crisp, with each syllable or character so small that they all fit neatly into the upper central section of the tanzaku, surrounded by the snow-covered red berries and evergreen leaves among scattered snowflakes in white pigment.

The third group of tanzaku consists of Tanzaku Three, "Hanging Wisteria Clusters," Tanzaku Four, "Flowering Orange," Tanzaku Five, "Morning Glories," and Tanzaku Six, "Red and White Chrysanthemums." The calligraphy here is not confined to the central area only, but continues to the bottom of the tanzaku in the scattered writing style. The most playful calligraphy pieces are those on "Wisteria" and "Morning Glories," in which the calligraphy, in scattered writing format, dances with the twisted vines and curling leaves of the wisteria and the morning glories. The painting style and texts of "Flowering Orange" and "Chrysanthemums" appear comparatively formal. The actual name of the flower does not appear in the poem of Tanzaku Four, "Flowering Orange." But the poem celebrates the longevity of the imperial line or courtly family line, since the *tachibana* ("Flowering Orange") has long been considered a divine tree (*shinboku*) in the history of Japan. Its flowers symbolize the everlasting imperial reign, and its green leaves, which do not easily shrivel up but stay fresh and green all winter, signify fidelity.

The waka in Tanzaku Four reminds the modern Japanese reader of the Japanese national anthem, *Kimigayo* or "Your Majesty's Reign," because the first, third, and fourth lines are comprised of almost exactly the same lyrics as those of the anthem. The exaggerated tone of praise in "To what shall we compare Your Majesty's reign?— / when it will last till tiny pebbles / have into mighty boulders grown" suggests that these sets of paintings may have been created for an occasion to celebrate the long reign of an emperor, or the longevity of the family line of a high-ranking minister. Tanzaku Six, "Chrysanthemums," bears a waka that was composed by Kiyohara Motosuke (908–990), the father of Sei Shōnagon, and was inscribed by Tonsured Prince

Shōren'in Son'yū (1698–1751) when he was in the rank of the Second Order. The poem is in the same laudatory tone, celebrating the ongoing generations.

This celebratory commemoration of a long life, or continuation of a fruitful life, surfaces even more clearly in the poems written on the shikishi. Shikishi One, "Blossoming Plums," expresses the poet's gratitude for the generosity of a person who sends the fragrant scent of plum blossoms even to such a humble person as himself. Shikishi Two, "Violet Gathering," composed by the retired eighty-third Emperor Tsuchimikado-in (1195–1231) and inscribed in calligraphy by Princess Tsuneko, suggests that the occasion of gathering violets in a spring meadow reminds her of a relationship that "tinged [her] sleeves pale lavender." In 1667, as on many occasions, Princess Tsuneko enjoyed *tsukushigari* (horsetail gathering) in the garden of the Jugetsukan, located in the lower tea garden of the Shūgakuin. According to her diary, on the second day of the third month in 1671, she accompanied Emperor Gomizuno'o on a walk from the lower tea garden to the upper garden, viewing cherry blossoms mixed with young green leaves, along with globeflowers and azalea.[10] There is no record to prove that the shikishi and tanzaku sets were produced in remembrance of Emperor Gomizuno'o, but this type of poetry set was probably made in honor of a personage like him.

Shikishi Three, composed by Priest Sosei (active late ninth century) and calligraphed by Kasanoin Sadamasa (1640–1704) after he retired from the office of Palace Minister, celebrates cherry blossom viewing. The poem expresses the feeling that the blossoms are too wonderful to be enjoyed only by those who have gathered to see them and encourages everyone to break off a flowering twig to take back as a souvenir to those who could not attend the viewing. It speaks of the overflowing abundance of beauty and a generous wish to share the enjoyment of the viewing. Shikishi Four, of unohana blossoms, composed by Nijōin Sanuki (an eleventh-century woman poet) and calligraphed by Nishinotōin Tokinari (1645–1724) after his retirement from the office of the Major Counselor, can also be read as a celebratory poem, asking a mountain cuckoo to usher us into summer's evenings since the unohana flowers are already in bloom and ready for the sacred celebration of the gods. Because the tiny white petals of the unohana

blossoms resemble grains of rice, the offering of the plant connotes the sacred Harvest Festival celebrated by the emperor.

Shikishi Five on irises, composed by Sanjōnishi Sanetaka (1455–1537) and calligraphed by Provisional Major Counselor Higashisono Motonaga (1675–1728), states that the name of the illustrious person will be recorded as someone who marks the changes, though the exact meaning of the marking is unclear. The poem is recorded in Sanetaka's private poetry collection, the most popular edition of which was published in 1670. In other words, when this set of shikishi was produced and the poem was selected, it was still a relatively new poem. It is very curious how these poems were selected to form a set like this; the sources were certainly not limited to the classical Heian poetry anthologies.

Shikishi Six on fringed pinks contains a poem composed in 1056 by Minamoto Chikamoto and calligraphed by Prince Fushimi Kuninaga when he was a Minister of Central Affairs. The poem rejoices in the flourishing of the thousands of shapes and hues of fringed pinks, a euphemism for the offspring of a family. Shikishi Seven on maidenflowers, composed by Minamoto Masakane (1079–1143) and calligraphed by Middle Counselor Nishisanjō Kimifuku (1697–1745), suggests that the source from which the autumn wind comes is the emperor or someone of nobility, because maidenflowers bow down and bend when the wind blows. Shikishi Eight on chrysanthemums, composed by Priest Gyōsai (fourteenth century) and calligraphed by Middle Counselor Kasanoin Tsunemasa (1700–1771), alludes to some type of jubilee, as it states, "Transplanted, / let your splendor last a thousand generations, / chrysanthemum. / Never aging, / may Your Majesty greet / innumerable autumns."

Shikishi Nine on maples, composed by Fujiwara Tameie (1198–1275) and calligraphed by Prince Arisugawa Bunnō (dates unknown), expresses the unusual beauty of the deepest crimson maple leaves, as though such beauty was never before seen in the Japanese archipelago. Shikishi Ten on pine trees entangled with the brightly colored ivy leaves was inscribed by Major Counselor Daigo Akitada (1679–1756) and honors an old pine tree that has the great responsibility of supporting the red ivy and maple leaves despite

heavy dew and frost on the tips of its branches. While not all the waka in these sets of shikishi and tanzaku support the idea that they were produced for a jubilee, or commemoration, the majority of the poems do.

In conclusion, it is clear that these two sets of shikishi and tanzaku were probably painted by a Tosa artist toward the end of the seventeenth century. Comparing these sets with the screen paintings held at the Chicago Institute, the Flower Court Poetry Cards are much smaller and consequently less expensive to produce, which suggests a creation date past the prime of the so-called Kan'ei culture initiated by Emperor Gomizuno'o and enthusiastically upheld by Tōfukumon-in. Even if we cannot completely rely on convent tradition for the identity of the calligraphers, their dates, taken together, indicate that the Flower Court Poetry Cards can be dated after Emperor Gomizuno'o's death in the year 1680.

When these Flower Court Poetry Card Sets were being produced, utensils for use at tea ceremonies were in great demand, but the hanging scrolls that were displayed at tea ceremonies were generally Southern Sung landscapes and bird and flower paintings, calligraphy by Zen priests (*bokuseki*), and waka calligraphy, for example, by Fujiwara Teika, which was a relatively new addition to the display scrolls. As discussed earlier, shikishi of the fragile and unstable nature of the Flower Court Poetry Cards are not easy to hang vertically.

I believe these sets were made for private use. Courtiers enjoyed games of various kinds and memorizing waka was one of the most important parts of their education. They were called upon to recite many poems on particular themes, like flowers, as in these sets. The way the poems were chosen makes sense only if the theme of flowers was chosen first and given to the calligraphers; the aristocrats would have found the most appropriate poems for the theme and the occasion and then brushed the calligraphy.

We know that Emperor Gomizuno'o loved the style of flower arrangement called *rikka*. A study informs us that he held more than thirty flower arrangement parties within six months in the year 1629.[11] So what could have been a more appropriate way of honoring him than creating paintings and calligraphy of poems on the theme of flowers?

Notes

1 Komatsu Shigemi, *Nihon shoseki taikan*, Vol. 6 (Tokyo: Kōdansha, 1978), plate 58. On tanzaku, see Maeda Toshiko, "Shikishi·Tanzaku 7: Tanzaku no okori," *Tankō* 330 (July 1974), pp. 153–156.

2 Association of Scientific Research on Historic and Artistic Works of Japan, *Painting and Sculpture of the Mary and Jackson Burke Collection and the Mary and Jackson Burke Foundation, New York*, Vol. 2, *Catalogue of Japanese Art in Foreign Collections*, p. 29.

3 Carolyn Wheelwright, ed., *Word in Flower: The Visualization of Classical Literature in Seventeenth-Century Japan* (New Haven, CT: Yale University Art Gallery, 1989), fig. 46 on p. 85 and figs. 59 & 60 on p. 104; and Elizabeth Lillehoj, "Flowers of the Capital: Imperial Sponsorship of Art in Seventeenth Century Kyoto," *Orientations*, 27: 8 (September 1996), fig. 12.

4 Kobayashi Tadashi and Murashige Yasushi, eds., *Shōshana sōshokubi—Edo shoki no kachō*, Vol. 5, *Kachōga no sekai* (Tokyo: Gakushū Kenkyūsha, 1981), plate 51.

5 Wheelwright, *Word in Flower*, figs. 14–18.

6 Kumakura Isao, *Gomizuno'o-in*, *Asahi hyōden sen* 26 (Tokyo: Asahi Shinbunsha, 1982), p. 246.

7 Komatsu, *Nihon shoseki taikan*; Maeda Toshiko, *Kinsei nyonin no sho* (Tokyo: Tankōsha, 1995), p. 69.

8 Komatsu, ibid., Vol. 13, plates 105–109.

9 Komatsu, ibid., calligrapher 34. Some Japanese scholars think there were two generations of Ozū—mother and daughter. See Maeda, *Kinsei nyonin no sho*, pp. 47-48.

10 Kumakura, pp. 246-247.

11 Ibid., p. 152.

尼僧寺院・大聖寺門跡所蔵「花の御所和歌」色紙と短冊について

大木貞子

京都の尼僧寺院大聖寺門跡に、現在十枚一組の色紙と、八枚一組の短冊が、所蔵されている。大聖寺の寺地が、将軍足利義満の室町殿、別名、花の御所から始まったこと、その上、四季の草花が色紙短冊からこぼれるように咲き誇っているので、本書では、「花の御所和歌」色紙短冊と、呼ぶことにした。ご存じのように、色紙は、ほんの少し縦の方が長いが、殆ど四角形で、短冊はと言えば、その名から連想できるように、細長である。日本の美術史、日本の詩の歴史の中で、両者とも大事な役割を果たしてきた。

　色紙は、多種多様であるが、歴史を遡ってみると、その理由が解かる。色紙の二字を「いろがみ」と読むと、それは正に、染料で染め付けた紙、のことで、平安の頃から、様々な「いろがみ」に詩を書き、風景画の描かれた屏風や襖の上方に貼るなどして、色紙形（しきしがた）と呼ばれていた。又、中には、冊子本、粘葉装であった物を切り離して、一頁づつにされた物も、色紙と呼ばれている。現存の中でも古く且つ有名なのは、1235年に藤原定家により書かれたという「小倉の色紙」である。十六世紀にはいり、茶道が盛んになると、茶掛けにして観賞できるように、切り離された書画もでてくる。歌合わせでは、色紙よりも懐紙が主に使われた。江戸初期の寛永三筆として有名な本阿彌光悦（1558-1637）が出現するに及んで、色紙は和歌を記録する美術価値のある手段として、注目を浴びるようになった。俵屋宗達（年代不詳1643年頃活躍）が意匠を凝らした下絵の版画の上に、光悦が書をしたためた色紙は、数多く伝来し、徳川時代の「粋」を象徴するかのようである。

　短冊の寸法には色々有るが、大聖寺門跡本は、八枚ともそれぞれ約、縦が、36.4cm、横が、11cmである。これは、細長い短冊の輪郭からはみ出した、花の描かれた部分を含めての寸法である。細長の短冊は、日本文学史上、鎌倉頃から

和歌そして後世俳句と、詩を記録する手段として良く使われたが、元々、木又は、紙で作られ、日本の初期の歴史では、紙の小片を撚って占いに使われた。和歌が書かれた紙製の短冊で、最古の物の一つと思われるものは、宗教色を帯びる。それは、1344年の年号をもち、足利直義（1306—52）が側近の者たちに、「南無釈迦佛全身舎利」の一音づつで始まる和歌の詠草を要請した時に作られたものである。[1] 室町時代に入ると、正式な歌合わせでも、懐紙・色紙とならんで短冊が盛んに使われ始めた。十五世紀末には、金銀で装飾された下絵入り短冊も現れ、その上に和歌を書くようにもなった。

　大聖寺門跡蔵、「花の御所和歌」色紙十枚と短冊八枚は、色々な意味で私達の興味をそそる。まずは、御所風の雅かさ、見慣れている四角や長細の角張った型からはみ出して咲き誇る花の絵、色紙短冊に書く常套手段以外の和歌の書き方、和歌の原典が広く十世紀から十六世紀に渡る勅撰集並びに私家集から選ばれていること、その上、書家達が、後水尾天皇（1596—1680）皇女を含む比較的知られていない宮廷人達であることだ。

　真っ先に気がつくことは、四季折々の草花、花木が、普通の色紙と短冊の上に収まりきらず、伸びやかに外へ張り出していることだ。正しく言い変えるならば、金銀泥が刷いてあり、金銀砂子や、細かい金箔が覆っている上に、極彩色で描かれた厚手の紙は、もとは、一まわり大きな紙であって、現在私達が見ているものは、そこから、切り抜かれたものと、言うべきなのである。(61頁掲載の色紙十番裏挿図参照)この色紙短冊の製作方法に似た種類の物は、北米では、筆者の知る限り、ほんの僅かに、バーク・コレクションに納められている「新古今和歌集六歌仙図」色紙、一組を数えるのみである。バーク・コレクション蔵は、大聖寺本より寸法が一まわり小さく、六枚一組で、景色に重点が置かれている。[2]

　色紙十枚それぞれは、花の描かれた張り出しの部分も含めて端から端まで約、縦19cm、横21cmで、どれにも、古典的な詩とその内容にそぐわしい四季の花が描かれている。絵は右下と左上に位置し、花々は、四角張った角には、収まりきらずに、悠々と咲き出しているが、少なくとも右上と左下の角はしっかりと直角

を保っている。(色紙によっては、他の角が残されているものもある。) 和歌の為の空間は、中央に残され、花が描かれている空間には介入しない。

　歴史的には、色紙は、屏風や帖に貼付されたり、掛け軸として縦に掛けられて観賞されたりしてきた。しかしながら、筆者が拝見した時には、この「花の御所和歌」は、畳、又は、机の上におかれ、大きめの黒い布張りの厚手の紙の上に、二箇所の直角の角がそれぞれ細い糸で押さえられていて、縦には飾ることが難しいと思えた。元は、屏風に貼付されていたのかもしれないし、バーク・コレクションの様に、折り帖になっていたのかもしれない。

　八枚の縦長の短冊も、普通の長四角形から花々が迫り出している。その花の位置は、縦の四分の三内に収まっており、四つの角は、全部直角を保っている。色紙と同様に、短冊も大きめの厚手の紙に黒い布を貼った上に載せられていた。細い短冊の一番下の部分は、交差した糸で押さえられていて、上部は横に糸が一本かけられ、理論的には、縦に飾ることが可能なように見受けられた。しかしながら、実際には、剥落の怖れもあるし、掛け軸のように、縦に展示するのは、危な気に見えた。

　脇にはみ出している草花は、実に丁寧に切り出されている。菊の花を囲むように描かれた非常に細くきゃしゃな秋草や、松の枝葉に絡み付いたり、長く垂れ下がる蔦、また、紅葉したもみじの葉など、誠に細かい手法を見せている。このような微に至る繊細な作品が、これ程良好な保存状態で今日まで来られたとは、信じがたい。絵からしても和歌からしても季題がはっきりしていることを考え合わせると、十二枚ではなく、色紙は十枚、短冊は八枚という数は、何枚かづつ不足しているということを物語っているのかもしれない。

　十八枚の表面には、落款も印も無い。個々の作品に、門跡寺院伝来の書家の名前が伝わるに過ぎない。一人の書家の名前が色紙と短冊一枚づつに伝わるので、全部で十七人の名が手元に残る。色紙と短冊の花の描き方や、紙の型を含む制作工程の、全体的な統一性を考え合わせると、少なくとも、色紙一組と短冊一組は、各々同じ時期に、或いは、特別な目的をもって、或いは、特別な機会

に合わせて制作されたと、言うことができると思う。そこで、この特別な機会というのが何であったのか、詳細はまだつまびらかではないにしても、今回、和歌の翻訳に当り、このこと、つまり、特別行事の様な設定を、念頭に置いた。書家達の年代を調べているうちに（図AとB参照）わかったことは、寺院伝来の鑑定を基にすると、全員が、一時期に一箇所に集合して制作することは不可能であった、ということである。例えば、色紙の場合には、一人の書家が亡くなった時には、もう一人が二歳であったり、短冊の場合には、一人が亡くなった年に、もう一人が生まれていたりする。作者の鑑定の伝来途中で、誤謬が生じたのかもしれないし、または、特別な機会というのが、何回もあって、このようなセットが、幾組も作られ、その中で混同がおきたのかもしれない。

　短冊に和歌を書く場合の伝統的な書式は、なかなかやかましく、規則が色々有るが、一般的なものは、上四分の一位は、季題用にとり、その下に、和歌は右から左へ縦二行に書く。続いて、和歌の作者の署名が左下に来る。もし、季題を除く場合には、第二行目は、一字下げて書きだす。歌人達は、最後に署名用に充分な場所が残るように、和歌を二行に書かねばならない。漢字が多すぎると、字数が、少なすぎて、空間が余ってしまう。なぜなら、漢字一つがいくつもの平仮名にとってかわるからで、逆に、仮名が、多すぎると、空間が足りなくなって、書ききれなくなる怖れがある。中世の細かな規則は、徳川時代にはいると、厳守されなくなる。和歌は二行には書かれたが、季題が、しょっちゅう削除されたり、長い序文が付け加えられたりした。短冊にも豪華な金銀の装飾が施されるようになる。例えば、金箔、様々な箔散らし（揉み箔と呼ばれる不定形にほぐした粉状に近い薄く延ばした箔など）、切り箔（直線的に切った小片）、砂のような微塵の金砂子などである。その上に、黒い墨で書が書かれるようになる。色紙、短冊、その他巻子本に、桜、卯の花、撫子、菊、すすき、鶴、浜松圖、など様々な植物、鳥、風景を描いた絵や版画の上に、書を書く慣例を、光悦が作り上げたといわれる。

　八枚の短冊を見てみると、季題も、署名も無いことに気付く。しかし、花の絵が、ほとんどの場合、季語の役を果たしている。署名が無いことは、和歌が、書家自身のものでは無く、古人の作から引用してきたことを示す。これらのことから、

通常の歌合わせの際に作られたものではないことが判明する。色紙も同様に、無季題、無署名である。十枚の色紙は、いずれも、描かれた絵を尊重し、和歌は、書用に残された空間に収められている。八枚の短冊のうち、第二番の有栖川幸仁親王（1656−1699）の伝承をもつ一枚だけは例外で、桜の咲き綻ぶ絵の上に、書を書いている。この例は、全部の十八枚のなかで、光悦によって始められ、後、十七世紀後半に非常に流行した書と絵画様式、後に琳派と呼ばれるようになるグループの作品に、一番近い。この「花の御所和歌」色紙短冊も、同じ、十七世紀後半に制作されたと、思われる。

　「花の御所和歌」に近似する作品は、シカゴ・アート・インスティテュートに保存され、1654年から1678年の間に制作されたと思われる、絵所の総帥、土佐光起（1617−1691）筆になる、六曲一双屏風の「桜花楓樹図」で、そこには、枝に和歌の書かれた短冊が結ばれて、風に揺れている。[3]　その外に、「花の御所和歌」に類似する作品は、兵庫県の頴仙美術館所蔵やはり土佐光起筆の「春秋花鳥図」である。[4]　上記両作品のなかに見られる、楓の葉の形や、その赤く染まった葉に、緑の染料を落としたり、銀で輪郭をぼかしたりする、色合いの変化の描写が、この色紙に見られる手法と類似する。その上、細部を詳しく見てみると、葉の中心から葉先に向かって線幅が一定の葉脈が、乱れなく、多くは金泥で入れてある手法も、上記の両作品にみられる。これも、短冊七番に見られる手さばきと類似する。その技術は、正確だが堅苦しくない。「花の御所和歌」に見られる和歌と絵の主題は、梅、すみれ、桜、卯の花、杜若、藤、橘、朝顔、撫子、菊、女郎花、楓、蔦の絡まる松、雪をいただく南天で、殆ど全部、伝統的な主題である。本草学の興隆を受けて後に人気が出てくる薬用の草花は見当たらない。科学的な目で見た正確さは無いが、自然観察に則た品の良い生気は、例えば、色紙二番のたんぽぽと蓮華草のかげにひっそりと咲くすみれの花に見ることができる。「花の御所和歌」の花の絵は、鳥や、風景に目をやらず、花そのものに集中しているし、かの有名な、藤原定家の十二箇月花鳥図とは、関連性を見いだすことはない。[5]

　特権商人達の庇護を受けて活躍した、琳派所属の画家達も、ひとつの画題に絞って描くことが多かったが、彼らの植物の描き方は、今迄に無い新奇の意匠を

心掛けたので、極力、文学への憧憬は、はっきりした形では表さず、目新しい抽象的なデザインを志向した。「花の御所和歌」に描かれた絵は、それとは異なり、絵画手法、好みの色調にしても、また、和歌という文学を前面に押し出していることから考えても、昔風の伝統美を継承する傾向を示す。光起を筆頭とする土佐派の画家の誰かが、描いたのではないだろうか。土佐派の絵は、保守的に見えるが、光起は、形骸化した伝統を固守したわけでは、決してない。彼が、宋や元の中国絵画の自然描写を学び、自家の宮廷様式を築いたということは、良く知られている。こういう光起風は、新しがりに陥ることなく、恐らく、十七世紀半ばから後半にかけて、徐々に経済的政治的には中心に位置しなくなった宮廷人の、昔を偲ぶ憧憬も含めて、彼らの趣向にかなったのではないだろうか。

　豪華な様式が今世紀やたらに宣伝されて有名になった琳派や、狩野派の手になる屏風と、「花の御所和歌」を比べてみて、何だか、かえって新鮮味を覚えるのは、私だけだろうか。大切にしまわれていた、優しみ溢れる旧御所風の古典文学表現の実在化であるこの色紙と短冊は、周辺に追いやられていた宮廷伝統の優雅さを、改めて見直してみようという気持にさせた。落款も直接の年代記録も無いので、誰がいつ描いたのか正確なことはいえないが、鮮やかな花木を描ききっている淀みない筆運びや、それの醸し出す雅かさは、やはり、光起ないしは、彼より少し後の土佐派の画家が描いたという説を支持すると思う。十七世紀にはいると、土佐派と狩野派とは、以前の様には対抗しなくなり、例えば、後水尾天皇の中宮の東福門院（1607–1678）は、京都の狩野派絵師に、多くの注文を出した。でも、日本の美術史のなかでは、土佐派と宮廷の縁は、一番深く、やはり、土佐派は人気があった。

　色紙の中の十人の書風の内に、はっきりと、三種類の様式を見ることができると思う。群を抜いて、目立つのは、十七人中唯一の女性であり、後水尾天皇皇女の、色紙第二番目の級宮（しなのみや）常子内親王（1642–1702）の書いた書である。彼女一人で一種類を構成する。常子内親王は近衛基熙の室になったが、父の後水尾天皇とは、生涯親しい間柄にあった。実は、天皇の死水を取ったのも、彼女であった。後水尾帝には、三十三人の子供があったが、少なくとも八人の娘

が尼になった。(図C参照)その内の多くは、夭折したが、常子内親王は、長生きして、父の山荘である修学院を何遍と無く訪れ、余暇を楽しんでいる。建物を愛で、お茶用の亭を周り、浴龍池を舟で巡り、点茶をし、食事の饗宴などで寛いだ。6

　常子内親王の書は、大変に風変わりである。余分なくるくる回る筆跡が目立ち、鈎を引っ掛けるような起筆やうねりの強い線は、一字のなかにすらはっきりと見て取れる。十八枚のなかで、彼女の書の判読が、一番難しかった。というのは、書風だけでなく、「散らし書き」と呼ばれる字の配置がより一層難しくしたからだ。和歌は、通常の右から左でなく、中央から書きだされ、左へ行き、戻って一番右へ行き真ん中のちょっと手前で終わる。中世には、「女房奉書」と呼ばれた書き方が流行り、天皇側近の女房達が、天皇の代筆をした際に、複雑な散らし書きを考案した。天皇自らが、「女房奉書」書きを真似て書いたものも今日伝存する。平安時代の書家達もこの散らし書きで和歌を書いたが、どうやら女性達が特に興味を持ち、発達させたようだ。色紙第二のすみれ摘みの和歌は、この散らし書きの好例である。内親王の手の判読には苦労したが、女性の書がこんなにも、他の男性諸君と違う事が分かって、私は、嬉しくて仕方がなかった。常子内親王は、自分の書が紛うことなく外の男性のものと異なり、しかも、配置の仕方も特別だということを、はっきり自覚してわざとそうしたのだろうか、是非とも知りたいところである。

　女性の書は、一般の書道全集には余り多くは掲載されていない。例えば、『日本書蹟大鑑』には、279例のうち女性のは、43例しかない。7　女性の書は、日本美術史のなかでも特に研究の遅れている分野である。常子内親王の書の水脈をたどってみて、次の発見をした。まず第一に、常子内親王の少し前に、小野お通（おずう）(1568–1631?)という、女性の書家が存在したということである。永いこと彼女の名前は"おつう"だと、思われていたが、つい最近になって、"おずう"と読ませている文書が見つかった。彼女は、徳川家康に駿府（現在の静岡）の居城に招かれて、婦女子に行儀作法を教授した。後、大阪城に入り、豊臣秀吉の妻淀君の信頼を得て、女性達に書と行儀作法を教えた。8

　現存のお通の書は、ゆったりと、大きく、流麗で、機知に富む。一般に我々が女性の書として抱く、小さく、繊細で、神経過敏な印象とは正反対で、小品も書いた

が、大字を好んだようで、いずれにせよ、いつも速筆で、淀みなく流れるようで、大げさな線質に特徴がある。彼女は、数筆で輪郭を書いた人物画が得意だったらしく、顔の部分のみ、伝統的な似せ絵の画法で細かに表現した画像が、残る。お通の速度の速い、しかも強く、力動感溢れる筆捌は、常子内親王の有り余るほどの線から構成される流麗な書風に、一つのヒントを与えてくれる。お通風は、百五十年もの間、上流婦女子の間で人気があったそうだ。[9] どうやらお通には先見の明があり、自分の置かれた機構内の立場を活かし、婦人達の興味を誘い、状況把握を怠り無く、教授に適した環境を作りあげたようだ。

　常子内親王の書風は、必ずしもお通のに、似ているとはいえない。但し、自由奔放で、しかもスピード感溢れる筆致には通じる所がある。実は、常子内親王の書は、私が今迄によく見知っている書のどれとも似ていないのである。短冊に和歌を記す時によく使用され、十四世紀に尊円親王によって始められた青蓮院流、また、その後、青蓮院流から派生して、十七世紀には幕府の公文書や、教科書の役割を果たした往来物に使われた、印刷代わりともいえるお家流にも、全く似ていない。波打つごとく、また、旋回するような筆致は、寛永の三筆の一人、松花堂昭乗（1584–1639）の流儀を思い起こさせるが、彼の流派に入れるほど類似してはいない。

　日本書道史全体を鑑みると、二点ほど常子内親王風に影響を及ぼしたかもしれないと思われる背景を思い浮かべる事ができる。一つは、"葦手"と、呼ばれる平安時代に始まった絵のなかに字をはめ込んだ戯れ絵である。例えば、水際の葦が生えている景色の中に和歌を盛り込んだりするもので、お通の人物画は、この葦手を確かに思い出させる。常子内親王の高度の螺旋質の筆運びは、葦手の絵画的影響に遡ると、言えるかも知れない。二つ目は、"花押"である。中世、署名の役割を果たした一字書き文字で、書き始めと終わりがどこなのか分からない様にした複雑な文字芸術である。常子内親王の書の錯綜とした書き振りは、花押に見られる隠された筆跡と相通じるものがある。彼女の書を分析するに当り、念頭に置くべきは、彼女の書風を既存の書風や、当時はやっていたと思われる流派に無理にはめ込もうとしないことだと思う。将来、まだ私達には未知の、地

方色の濃い、或いは、ジェンダー別の、書の研究分野が開けてくるかもしれない
という可能性もあるのだから。

　色紙の書の第二番目のグループは、五番「かきつばた」、六番「撫子」、七番「女
郎花」、それに、九番の「楓」からなる。これらの書風は、常子内親王のと比べる
と、一概に、線質の太い箇所が散見し、線の表現に強調された部分が見受けら
れる。この組に属する書は、それぞれ、行の始まりが右上から徐々に左へ移行す
るに従い、背が低くなり、花や葉の描かれた部分には、書は少しもかからない。
此の組に属する宮廷書家達の書は、殆どどこにも出版されていないので、個人
個人の書風を云々することはできない。しかしながら、彼らの書風は、当時流行
の、本阿彌光悦、松花堂昭乗、烏丸光廣、または、お家流には、似ていないこと
は確かである。

　第三番目の組は、五枚の色紙から成り立つ。一番「咲き誇る梅」、三番「八重
桜」、四番「卯の花」、八番「菊」、そして、十番の「蔦の絡まる松」である。このグル
ープの書体は、残りと比べると、ずっと線が細く、肥痩の変化に乏しい。この組
の書も、当時流行の書体を思い起こさせるものではなく、自然体で、平安時代の
伝藤原行成作の書作品に代表される古典仮名に、似ている。ここで、注記したい
のは、常子内親王の息子、近衛家熙（1667-1736）が、行成風の古典書道を得意
としたことだが、現在、彼の努力は充分に評価されているとは言えない。特権商
人達の平安朝の雅の復興運動によって創作された書風は、今日まで、強調され
てきている反面、十七世紀から後の宮廷書風というのは、面白みがなく、末梢的
だと、敬遠されてきた。ほんの少し、家熙の行成風が、代表として知られているだ
けで、徳川時代に宮廷風の書がどうなったのかは、余り研究されてきていない。
しかし、今ここで、「花の御所和歌」に、その答えを垣間見ているような気がする。

　八枚の短冊も、書風と作品枠への収め方から同じく三組に分けられる。前に
述べたように、短冊二番の「咲き誇る桜」だけは、描かれた絵の上にまで書が及
んでいるので、それで一つの組を構成する。桜の絵が季題の替わりにはなって
いるが、此の和歌だけは、又、伝統的な和歌の記載法に則て、はっきりと縦二行
に書かれている。書風も、残りの短冊とは違う。書家は、絵の上に字を書くこと

を怖れてはいないので、漢字仮名の大きさも外の例よりかなり大振りだ。寺院伝来によると、書家は、後西天皇の子息、有栖川幸仁親王で、つまり、後水尾天皇の孫にあたる。

　この短冊二番に書かれた和歌には問題がある。十八枚の内、短冊七番を除いて殆ど全部、和歌の出典は判明したのだが、ここに書かれた和歌はほんの一部、解読の困難な箇所がある。和歌の第三行目が、出典に掲載されている句と異なる。句は、有名な西行法師の句にとても近似しているが、西行の句は、「奈良の生駒岳に雲がかかっているから、秋篠の里には、時雨れが降っているのであろうか。」という、寂しげな雨にしょぼ濡れた和歌である。どう考えても、咲き誇る桜の短冊には、似つかわしくない。短冊に書かれた字の詳細を調べてみると、肝心な箇所の墨付きが悪く、しかも、木の幹の上に字が書かれていて、判読が難しいが、三行目の読みが、西行のと違うと、桜の絵に合う。西行のは、「時雨るらん」だが、幸仁親王のは、「時ならん」（もう、そんな、時節であろうか）と、読める。そう解釈すると、意味が通じる。つまり、幸仁親王は、此の句が、桜を雲に見立てて詠んでいると解釈したようだ。その過程で、親王が、間違えてそう詠んだのか、或いは、わざと、知っていながら古典を自分なりに解釈して、新しい句を編んだのかは、現段階ではわからない。字の上での問題は、草書で書かれた漢字の「時」の下に、同じく草書の（1）「雨る」（西行）なのか、それとも、（2）「な」（親王）だけなのか。が、争点になる。こんな、些細な点で、意味は全くことなってしまうのだから、大変面白いし、恐ろしい。字の解読の醍醐味ともいうべきところだ。

　第二番目の組は、短冊一番「中心が紅い梅」、七番「紅葉の楓」、そして、八番「雪中南天」からなる。此の組は、書風で分けたのではなく、和歌を書く配置の仕方による。この組の書家達は、短冊の中ごろに空けられた場所にだけ収まるように、書いている。書風は一人一人異なる。伏見中務卿邦永親王（1676—1726）の名前は、短冊七番と、色紙六番「撫子」の二作品の書家として伝わる。両方の書風を比べてみると、同一人物によると思える。邦永親王の書風は、のんびりとしていて、八番の七條宰相隆豊卿（在官1670—1686）の小回りのきいた、はきはきした字と、対象的である。宰相の和歌は、雪を被った南天の常緑の葉と赤い実、

その積雪をさらに飾る白い粉雪にさえも触れずに、かなり狭い空間にきちんと収められている。

　短冊第三番目の組は、三番「藤」、四番「橘」、五番「朝顔」、六番「紅白の菊」からなる。此の組に属する書は短冊の中心部の余白だけでなく、短冊の底辺部にまでも及び、散らし書き風にしたためられている。このグループのなかで、しゃれっ気のあるのは、三番の「藤」と五番の「朝顔」で、書も絵と呼応して、くりくりした藤蔓や葉、弧を描く朝顔の蔓真似るかのように書かれ、踊っているように、散らしても書いてある。一方、「橘」と、「紅白の菊」は、描き方からしても、和歌の内容からしても、まじめである。短冊四番は、実は、和歌の中に橘の名前は現れない。詩のなかには、天皇家或いは、宮廷人の世代の永続への願いが込められている。橘の木は、日本史の中で、神木と見做されている。なぜならば、緑の葉はつやつやとして、いつまでも新鮮で水気を失わず、茶色く枯れる事が少ないので、その花は、永続する御世と忠誠心の象徴なのである。短冊四番の和歌は、日本の国歌「君が代」を、連想させる。というのは、詩の一、三、四行目の言葉が、殆ど国歌に出てくる言葉と瓜二つなのだ。和歌は、「君が代を　なににたとえんさざれ石の　巌とならん　程もあかねば」である。此の歌から察すると、「花の御所和歌」色紙短冊は、天皇家の、ないしは、高位の宮人の、御代の存続を祝う、或いは、長寿を祝う目的で制作されたのではないかという結論に達する。短冊六番、「紅白の菊」の和歌は、清少納言の父、清原元輔（908–990）作で、青蓮院二品尊祐法親王（1698–1751）が書を書いたとされる。この和歌も同様に、万世もの間不老長寿を約束するという白露が、自分の家の菊に下ります様に、という願いをこめている。

　色紙に書かれた和歌全体を通してみると、長寿の祝賀、或いは、世代の存続への願い、という主題は、更にはっきりしてくる。色紙一番「花開く梅」の和歌では、自分の様な詩の作者にさえも惜しげ無く香を送ってくれる梅、に対する感謝の気持を詠んでいる。色紙二番「すみれ摘み」は、第八十三代天皇土御門院（1195–1231）御製で、唯一女性の常子内親王の書になる和歌で、春の野原でのすみれ摘みは、着物の袖を薄紫に染める宿縁を思い起こさせる、と詠んでいる。

1667年にも、他の多くの機会と同様に、常子内親王は、修学院山荘の、下のお茶屋の寿月観の庭で、土筆採りをして楽しんでいる。彼女の残した日記には、色々な記載があるのだが、1671年3月2日には、例えば、後水尾天皇のお伴をして、下の茶屋から上の茶屋まで行き、その間に、青葉に混じった桜を観賞し、山吹、躑躅も楽しんでいる。[10] この「花の御所和歌」が、後水尾天皇を祝って、或いは思い出して、作成されたという証拠は、今のところ無いのだが、彼のような人物の祝賀記念に、作られたのではないのだろうかと、思えてならない。

色紙三番「咲き誇る桜」の和歌は、素性法師（9世紀末活躍）作で、花山院前内大臣定誠卿（1640–1704）の書で、花見を謳歌している。お花見に来られた者たちばかり、楽しんでいたのではもったいない。てんでに枝を折って行って、皆にお土産にしましょう。と、いうのである。この和歌には、溢れるばかりの自然美と、悦楽を皆で分かち合おうという大らかさが横溢している。色紙四番「卯の花」の和歌は、二条院讃岐（11世紀女性詩人）作で、西洞院前大納言時成卿（1645–1724）の手になる。これも、卯の花の花びらが、細かく、白い米粒に似ているところから、天皇によって執り行われる神聖な新嘗祭を連想させる。和歌は、神に捧げる卯の花も咲いたので、山時鳥よ、夏の訪れを告げて鳴いておくれ。というものである。

色紙五番「かきつばた」の和歌は、三条西実隆（1455–1537）の作で、東園権大納言基長卿（1675–1728）の書である。此の和歌も、詳しい事情はわからないにせよ、春と夏を隔てる人、なにか変化を起こす人物として、名前が残るでしょうと、いっている。この和歌は、実隆の私家集『雪玉集』に収録されていて、この家集の一般に流布した版は、1670年に出版されたので、この色紙の制作にあたって、和歌が選ばれた時点では、かなり新しい歌として数えられていたかもしれない。いったいどのようにして、これらの和歌は集められ、色紙に書かれたのであろうか、興味はつきない。平安時代の古典和歌選集だけからの出典に限られてはいないことは、確かだ。

色紙六番「撫子」の和歌は、源親元が1056年に詠んだもので、書は、伏見中務卿邦永親王の手により、子孫を種々の撫子に喩えて、千種類もあるかと思えるほどの花々が咲いている、という情景を詠んでいる。色紙七番は、「おみなえし」で、

和歌は、源雅兼（1079—1143）で、書は三條西中納言公福卿（1697—1745）の筆跡で、女郎花が秋風に吹かれて、お辞儀をしている様子を詠んでいるが、風の吹いてくる源を、天皇或いは、誰か高貴な生まれの人と解釈しているように思える。色紙八番は「菊」で、法眼行済（14世紀活躍）の和歌、書は、花山院中納言常雅卿（1700—1771）による。和歌は、おめでたい記念祝賀の詩である。口語訳にしてみると、「移し植えたのですから、千代までも匂って欲しい。菊の花よ。あなたが老いることなく、秋を重ねて永遠に薫り高くありますように。」と、歌っている。

　色紙九番「楓」の和歌は藤原為家（1198—1275）、書は、有栖川文応宮（年代不詳）で、大和には、見当たらない韓紅色に染め付けた様な紅葉の鮮やかさを愛でている。色紙十番は、赤く染まった蔦の絡まる松で、和歌の作者の氏は不明だが為道の作、書は、醍醐大納言昭尹卿（1679—1756）による。露や霜がかかっている松の梢には、蔦や紅葉も絡まっているので、なかなかの責任重い立場にいる松を詠んでいる。これまでみてきたように、全部が全部祝賀の記念の和歌とは、言い切れないが、殆どは、何か特別記念の為に集められたと言えると思う。

　十七世紀末頃、「花の御所和歌」色紙短冊二組は、多分、土佐派の画家により描かれたと思う。シカゴ・アート・インスティテュート所蔵の豪華な屏風絵と比較すると、この二組はずっと小振りだ。これは、後水尾天皇によって始められ、東福門院により奨励されて花咲いた、所謂、寛永文化の、盛りを過ぎた頃を暗示しているのではないだろうか。大聖寺門跡の寺院伝来の書家達の名前を百パーセントは、信頼出来ないにせよ、彼らの年代もやはり、後水尾天皇の死後1700年前後を支持しているように思える。

　この色紙短冊が制作された頃、茶道用の様々な茶器や、茶掛けの需要があった。しかし、床の間に飾られた茶掛け用の軸は、南宋の山水画や花鳥画、禪の墨跡、などが主流を占め、それに加えて新しく藤原定家の書が、観賞され始めていた。この序文の最初に述べたことからも分かるように、特に「花の御所和歌」色紙は、縦に掛けるのは難しい状態である。とても、茶掛け用には向かない。

　「花の御所和歌」は、個人的な用途の為に作成されたと思う。宮廷人達は、色々なゲームを楽しんだが、古人の和歌をまず暗記することは、彼らの教育のなかで

も特に大切な部分を占めた。何か特別に選択された主題に関して、詩歌を詠むことは、しばしばで、ここでは、多彩な花々について詠む機会があったわけだ。あっちこっちの出典から選ばれた和歌は、先に花題が選ばれていたとすると、納得がいく。その花題が、宮廷の書家達に配られ、そして、書家は一人一人その花と特別な機会にちょうど適う和歌を選び、書いた。

　後水尾天皇は、「立花」、生け花の愛好家であった。文献によると、1629年には、たった六箇月の間に、三十以上の立花の会を催したといわれる。[11]　この天皇を偲ぶ人々が集まる機会に、花にまつわる和歌を詠み、そして書く。それ以上にどんなふさわしいことが、考えられるだろうか。

注

1.　小松茂美、『日本書蹟大鑑』。東京：講談社、1978、第6巻、図58。短冊については次を参照。前田詙子、"色紙・短冊（七）短冊のおこり"『淡交』330（1974年7月）、153～156頁。

2.　Association of Scientific Research on Historic and Artistic Works of Japan 古文化財科学研究会、*Painting and Sculpture of the Mary and Jackson Burke Collection and the Mary and Jackson Burke Foundation, New York* ニューヨーク バーク・コレクション バーク・ファウンデーション 絵画・彫刻、*Catalogue of Japanese Art in Foreign Collections*、海外所在日本美術品調査報告、1992、第2巻、29頁。

3.　キャロライン・ウィールライト編集、Carolyn Wheelwright, ed., *Word in Flower: The Visualization of Classical Literature in Seventeenth-Century Japan* New Haven, CT: Yale University Art Gallery, 1989、頁85の図46と、頁104の図59と60。エリザベス・リレホイ、Elizabeth Lillehoj, "Flowers of the Capital: Imperial Sponsorship of Art in Seventeenth Century Kyoto," *Orientations*, 27: 8 (September 1996)、図12。

4.　小林忠、村重寧編、『瀟洒な装飾美—江戸初期の花鳥、花鳥画の世界』、学習研究社、1981、第5巻、図51。

5. ウィールライト、前掲書、図14—18。

6. 熊倉功夫『後水尾院』朝日評伝選 26、朝日新聞社、1982、246頁。

7. 小松、前掲書。前田詇子『近世女人の書』東京：淡交社、1995、69頁。

8. 小松、前掲書、第13巻、図105〜109。

9. 小松、前掲書、第13巻、書家34番。おずうは、母と娘二代に渡ったという説もある。前田、前掲書、47〜48頁。

10. 熊倉、前掲書、246〜247頁。

11. 熊倉、前掲書、152頁。

Bibliography

参考文献

Ama monzeki shorui 尼門跡書類, unpublished record, preserved at Shoryōbu 書陵部, Kyoto, handcopied in 1923.

Arakawa Reiko 荒川玲子, "Keiaiji no enkaku—Ama gozan kenkyū no ikku" 景愛寺の沿革—尼五山研究の一齣, *Shoryōbu kiyō* 書陵部紀要, no. 28, 1976.

Association of Scientific Research on Historic and Artistic Works of Japan 古文化財科学研究会, *Painting and Sculpture of the Mary and Jackson Burke Collection and The Mary and Jackson Burke Foundation, New York* ニューヨーク バーク・コレクション バーク・ファウンデーション 絵画・彫刻, *Catalogue of Japanese Art in Foreign Collections* 海外所在日本美術品調査報告, Vol. 2, Tokyo, 1992.

Hayashiya Tatsusaburō 林屋辰三郎, *Nihon bunka shi* 日本文化史, Tokyo: Iwanami Shoten 岩波書店, 1988.

Ichikawa Seigaku 市川青岳, *Kinsei joryū shodō meika shiden* 近世女流書道名家史伝, Tokyo: Nihon Tosho Center 日本図書センター, 1991.

Ishikawa Tadashi 石川忠, et al., *Kyō no miyabi—Kyū gosho ten* 京の雅・旧御所展, Tokyo: Asahi Shinbunsha 朝日新聞社, 1986.

Kawashima Masao 川嶋将生, *Chūsei Kyōto bunka no shūen* 中世京都文化の周縁, Tokyo: Shibunkaku Shuppan 思文閣出版, 1992.

Kinoshita Masao 木下政雄, "Shikishi・Tanzaku 1~6" 色紙・短冊(一)~(六), *Tankō* 淡交, nos. 324~329 (January~June 1974).

Kobayashi Tadashi, Murashige Yasushi, eds. 小林忠、村重寧編, *Shōshana sōshokubi—Edo shoki no kachō* 瀟洒な装飾美—江戸初期の花鳥, *Kachōga no sekai* 花鳥画の世界, Vol. 5, Tokyo: Gakushū Kenkyūsha 学習研究社, 1981.

Komatsu Shigemi 小松茂美, *Nihon shoseki taikan* 日本書蹟大鑑, Tokyo: Kōdansha 講談社, 1978.

Kumakura Isao 熊倉功夫, *Gomizuno'o-in* 後水尾院, *Asahi hyōden sen* 朝日評伝選 26, Tokyo: Asahi Shinbunsha 朝日新聞社, 1982.

Lillehoj, Elizabeth, "Flowers of the Capital: Imperial Sponsorship of Art in Seventeenth Century Kyoto," *Orientations*, 27: 8 (September 1996), pp. 57-69.

Maeda Toshiko 前田詇子, *Kinsei nyonin no sho* 近世女人の書, Tokyo: Tankōsha 淡交社, 1995.

Maeda Toshiko 前田詇子, "Shikishi・Tanzaku 7~12" 色紙・短冊（七）~（十二）, *Tankō* 淡交, nos. 330~335 (July~December 1974).

Nakata Yūjirō 中田勇次郎 ed., *Hon'ami Kōetsu* 本阿彌光悦, *Shodō geijutsu* 書道芸術, Vol. 18, Tokyo: Chūō Kōronsha 中央公論社, 1982.

Narazaki Muneshige 楢崎宗重, "Tosa Mitsuoki hitsu ōka fūjuzu byōbu" 土佐光起筆櫻花楓樹圖屏風, *Kokka* 国華, no. 789 (December 1957).

Oka Yoshiko 岡佳子, "Omuro chitsu—Bunken shiryō wo chūshin ni" 御室窯—文献史料を中心に, *Tōyō Tōji* 東洋陶磁, no. 18 (December 1990).

Oka Yoshiko 岡佳子, "Bunchi Joō to Tōdōke—Yamamura Enshōji kaisō ni itaru made" 文智女王と藤堂家—山村円照寺開創にいたるまで, *Kamo bunka kenkyū* 賀茂文化研究, no. 2 (November 1993).

Oka Yoshiko 岡佳子, "Mō hitotsu no Kan'ei bunkaron—Buke to dōgu no kankei" もうひとつの寛永文化論―武家と道具の関係, *Kyoto-shi rekishi shiryōkan kiyō* 京都市歴史資料館紀要, no. 10 (February 1997).

Osaka Shiritsu Bijutsukan 大阪市立美術館, *Kōetsu no sho—Keichō, Genna, Kan'ei no meihitsu* 光悦の書・慶長・元和・寛永の名筆, Osaka: Osaka Shiritsu Bijutsukan 大阪市立美術館, 1990.

Shimizu Yoshiaki, John Rosenfield, et al., *Masters of Japanese Calligraphy 8th–19th Century*, New Haven, CT: Eastern Press, 1984.

Takebe Toshio 武部敏夫, "Ama monzeki jiin no enkaku" 尼門跡寺院の沿革, *Monzeki amadera no meihō* 門跡尼寺の名寳, Tokyo: Kasumi Kaikan 霞会館, 1992.

Takeda Tsuneo 武田恒夫, *Momoyama no bijutsu* 桃山の美術, Tokyo: Iwanami Shoten 岩波書店, 1992.

Tokyo Kokuritsu Hakubutsukan 東京国立博物館, *Tokubetsu ten "Nihon no sho"* 特別展日本の書, Tokyo: Tokyo Kokuritsu Hakubutsukan 東京国立博物館, 1978.

Tsuji Nobuo 辻惟雄, et al., *Nihon byōbue shūsei* 日本屏風絵集成, Vol. 6: *Kachōga—Kaboku kachō* 花鳥画―花木花鳥, Tokyo: Kōdansha 講談社, 1978.

Wheelwright, Carolyn, ed., *Word in Flower: The Visualization of Classical Literature in Seventeenth-Century Japan*, New Haven, CT: Yale University Art Gallery, 1989.

Yamane Yūzō 山根有三, et al., *Nihon byōbue shūsei* 日本屏風絵集成, Vol. 7: *Kachōga—Shiki kusabana* 花鳥画―四季草花, Tokyo: Kōdansha 講談社, 1980.

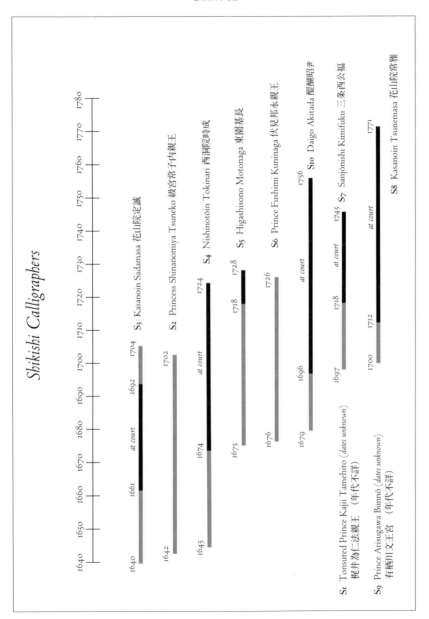

Chart A

Shikishi Calligraphers

Tanzaku Calligraphers

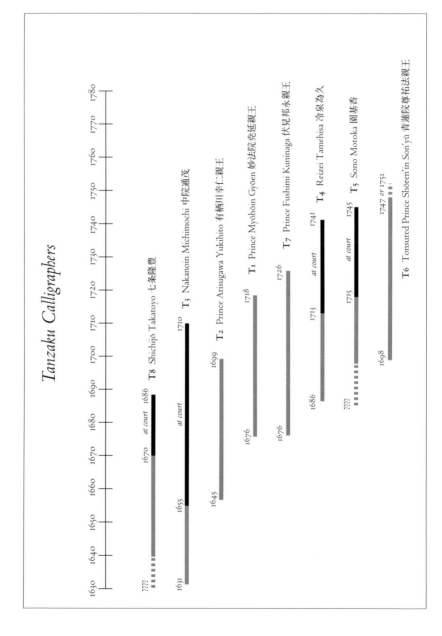

Chart C

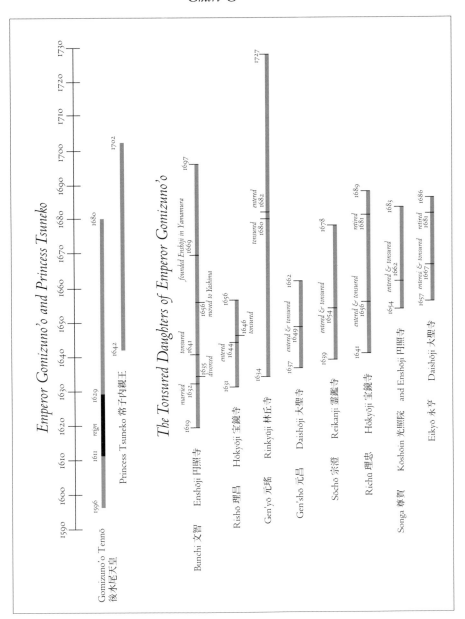

Emperor Gomizuno'o and Princess Tsuneko

Gomizuno'o Tennō 後水尾天皇

Princess Tsuneko 常子内親王

The Tonsured Daughters of Emperor Gomizuno'o

Bunchi 文智 — Enshōji 円照寺

Rishō 理昌 — Hōkyōji 宝鏡寺

Gen'yo 元瑤 — Rinkyūji 林丘寺

Gen'shō 元昌 — Daishōji 大聖寺

Sōchō 宗澄 — Reikanji 霊鑑寺

Richū 理忠 — Hōkyōji 宝鏡寺

Songa 尊賀 — Kōshōin 光照院 and Enshōji 円照寺

Eikyō 永亨 — Daishōji 大聖寺

95

Translators' Note

Herschel Miller

All of the poems in the Flower Court Poetry Cards were selected by their calligraphers from earlier imperial poetry anthologies, such as the *Kokin waka shū*, the *Shin kokin waka shū*, and various "private" anthologies (*shishū*). Some had originally been composed as love poems. A few had already been translated into English prior to the compiling of this book, and most of these English translations are excellent ones. Yet for the purposes of this book we decided to retranslate each poem, rather than rely upon the existing translations. Our reason for doing so is that the translations in this book are shaped by a specific working assumption: that the *shikishi* and *tanzaku* of the *Hana no gosho* or Flower Court Poetry Card sets were created as an organized, concerted gesture of homage toward an illustrious personage—probably an emperor or a member of his immediate family—to mark a specific social occasion.

Unfortunately, we have no conclusive proof that this assumption is correct. Yet the circumstantial evidence surrounding the Flower Court sets is compelling. First, the fact that the works are all done on identical shikishi or tanzaku media, despite the fact that they were written by many different calligraphers, suggests each of the two sets was created as a single, centrally organized project. Moreover, it seems unlikely that these projects extended over many years' time, since if they had, one would expect to find more variation in the physical media themselves, and probably in format as well. Second, the fact that the paintings all appear to be the work of the same painter strongly reinforces this view. Third, the very high social standing of the sixteen men and one woman to whom temple tradition ascribes the calligraphy of the poetry sets indicates that, assuming the sets were indeed each prepared for an organized event, they must have been organized at quite a high level; and this in turn lends weight to the notion that the event was one connected with a very high personage, such as an emperor—perhaps on the

occasion of a change of imperial reign, a change of calendrical era (*nengō*), a
longevity celebration, or some other such milestone.

If our assumption is in fact correct, it follows that all of the poems in the
sets, including those that appear to be love poems, are to be seen rather as
courtly gestures of homage, as formal salutations, probably to an emperor.
Thus the love poems are given a twist: the theme of amorous longing is
employed as an elegant metaphor for the feelings of longing and devotion
appropriate to one's attitude toward a ruler. Our English translations take
this interpretation as a working premise, and accordingly seek to bring out
those nuances that suggest amorous love as a metaphor for courtly fealty.
Our translations also seek to reinforce the feeling that the poems in these
sets were intended for formal presentation together with other poems, so
that they mean to be speaking on behalf of an entire group, as well as of a
single individual. Thus, for example, in Shikishi Two,

> *Sumire tsumu*
> *haru no nohara no*
> *yukari areba*
> *usumurasaki ni*
> *sode ya some ken*
>
> Can it be this gathering of violets
> in a spring meadow
> that has tinged my sleeves pale lavender?

the phrase "gathering of violets" is intended not only to render *sumire tsumu*,
"picking violets," but also to bring out a potential resonance of the word
yukari. *Yukari* is taken to mean "a karmically predestined bond between us
two" when the verse is read as a love poem, but can also be taken to mean
a karmic bond or blood relations between the members of a larger group,
and thus to imply an assembly, or "gathering," of aristocrats.

Likewise, Tanzaku Five,

> *Yamagatsu no*
> *kakiho ni sakeru*
> *asagao wa*

shinonome narade
au yoshi mo nashi

Only at the break of day
am I favored with a glimpse
of the morning glory
blooming on the fence
of a mountain hut

would probably be read by most Japanese readers as a love poem: on return-
ing home at dawn from a secret midnight tryst on the outskirts of town,
the poet rues the fact that his opportunities to see (*au*, which literally means
"meet") his lover are as rare as the sight of the morning glory he saw
blooming on the hedge on his way home. Thus an equally valid, and per-
haps more natural, translation might be:

Only at the break of day
can I see her face:
the morning glory
blooming on the fence
of a mountain hut.

Nevertheless, we opted for the rendering "favored with a glimpse/of the
morning glory" on the assumption that, in this context, the image of the
rarely glimpsed morning glory (whose name in Japanese literally means
"morning face") is meant to suggest a rare and precious opportunity to
actually see the face of the emperor (or some other very illustrious person).

In this sense, the translations found here often do not represent the most
straightforward interpretations of the poems as individual works. Rather,
they are an attempt to interpret them in the context of the specific social
event for which we speculate the Flower Court Poetry Cards were created.

翻訳者より

ハーシャル・ミラー

「花の御所和歌」色紙短冊記載の和歌は皆、それを書いた書家によって、『古今和歌集』、『新古今和歌集』等の勅撰和歌集、並びに、いくつかの私家集より選ばれている。その歌の幾首かは、もとは、恋歌として詠まれた。本書を編む以前に、その幾つかは英訳されていて、皆優れた翻訳である。しかし、この本の出版目的に添うため、既に翻訳されているものによらずに、今回、全部一首づつ、訳し直すことにした。その理由は、この翻訳は、次のような仮説に基づいてなされているからだ。つまり、「花の御所」の色紙と短冊は、誰か高貴な人物の、例えば、天皇あるいはその家系にまつわる人への表敬、という何か特別記念祝賀の意味合いをもっていると、想定しているのである。

　しかしながら、この想定を裏付ける決定的な証拠はない。だが、大聖寺門跡本に紆る状況判断からして、その他のことは考えにくい。まず第一に、色紙と短冊それぞれ、何人もの書家によってしたためられてはいるものの、同じ、色紙・短冊の紙形、描き方を含む「型」を保持している、ということを考えると、何か一つの目的をもって作成されたと考えられる。その上、この企画が、長年に渡って続いたとは思えない。なぜなら、長期間に渡ったのだったら、製作工程でもっと変化が生じたはずだし、「型」も、変わらないはずはなかったであろう。第二に、絵全体が、多分一人の画家によって描かれたと思われることが、これを支持する。第三に、「花の御所和歌」の書家として、尼寺院の伝承が、上層階級の宮廷人である十六人の男性と、一人の女性書家の名を挙げていることを考えてみても、何か高位の人々の間で組織だった計画のもとに作成されたと、考えるのが自然だと思う。そして、このことが、誰か天皇に代表される高貴な人物を讃美する催し、例えば、天皇即位、新年号の制定、長寿の祝賀、等の特別記念行事を、指し示しているといえないだろうか。

　もし、我々の想定が事実正しいならば、もとは恋歌だったかもしれない歌を含めて和歌はすべて、恐らく天皇に対して示される敬慕の念を表現する手段として、宮廷での格式張った要素を持つと思う。そこで、書家達は、恋歌を直接男女間の恋心を表わしていると解釈せずに、一捻りさせている。つまり、愛情は、君主に対して抱く思慕、崇拝の念を表す高雅な比喩として、捉えられている。ここでの英訳は、この解釈を前提としていて、愛慕は、宮廷における臣下の忠誠心が微妙に顕れるように、心掛けた。そしてまた、和歌一首づつが、他の和歌と一緒になって、正式な贈呈に適う作品であると、書家達によって見做されていたから、一人づつが語っているだけでなく、皆の声ともなっていると見做した上で、翻訳した。そこで、例えば、色紙第二番の、

　　　　菫菜摘む　春の野原の　ゆかりあれば　薄紫に　袖や染けむ

「春の野原のすみれ摘みの行事には、何か縁があるのでしょうか。私の着物の袖は、薄紫色に染まりました。」の中で、「すみれ摘み」は、唯単に、菫を摘むことだけを指すのでなく、「ゆかり」という言葉の裏に潜む、ある響きを引き出すように、翻訳した。「ゆかり」は、つまり、恋歌では、「二人の間の、前世からの約束事であるつながり」であるが、ここでは、より広い意味のつながりであるところの、宿縁、血縁関係、つまり、高貴な人々の集合体を指している。

　同様に、短冊第五番、

　　　　山がつの　かきほにさける　朝がほは　しのゝめならで　あふよしもなし

「山里の樵が住みそうな小屋の垣根に咲く朝顔は、夜明けでなくては会うことができない。」は、恋の歌として次のように解釈するのが、普通であろう。人里離れた所での夜の密会後、明け方近く家路を急いでいて、ふと朝顔が目についた。垣根に咲くその朝顔に会うのは、彼女に「会う」のと同じように、なかなか難しいのだと、詩人は嘆いている。一方、我々の翻訳は、朝廷で帝に拝謁するという、

意味合いを覗かせた意味での「会う」で、敬意をはらわれる特別な高貴な人物には、なかなか拝謁できないと云うことを、ほのめかしている。

　この意味で、ここに掲載される翻訳は、一句づつそれだけを訳した通常の自然体の翻訳と、異なる場合がある。それは、この大聖寺門跡寺院の和歌が作られたであろう特別な行事を、念頭においているからなのである。

Notes to the Poems

Shikishi 1

CALLIGRAPHER: Tonsured Prince Kajii Tamehito of the First Order (dates unknown).

WAKA AUTHOR: Asukai Masaari (1241–1301), courtier and poet of the late Kamakura period.

WAKA SOURCE: *Shin shoku kokin waka shū* (New collection of ancient and modern Japanese poetry, continued), Vol. 1, "Spring I," no. 71. The twenty-first and final imperial poetry collection, completed in 1439.

Shikishi 2

CALLIGRAPHER: Princess Shinanomiya Tsuneko (1642–1702), daughter of Emperor Gomizuno'o.

WAKA AUTHOR: Retired Emperor Tsuchimikado (1195–1231, reigned 1198–1210).

WAKA SOURCE: *Dairin gushō* (My foolish selections from the forest of poetic topics). "Spring IV," no. 1385. Private collection, completed between 1447 and 1470. Attributed to Yamashina Tokio.

Shikishi 3

CALLIGRAPHER: Former Palace Minister Kasanoin Sadamasa (1640–1704). At court 1661–1692; took the tonsure in 1692.

WAKA AUTHOR: Priest Sosei. Early Heian period poet, active late 9th c.

WAKA SOURCE: *Kokin waka shū* (Collection of ancient and modern Japanese poetry), Vol. 1, "Spring I," no. 55. The first imperial poetry collection, completed 905.

Shikishi 4

CALLIGRAPHER: Former Major Counselor Nishinotōin Tokinari (1645–1724). At court 1674–1724.

WAKA AUTHOR: Nijōin Sanuki, late Heian period poetess.

WAKA SOURCE: *Shoku senzai waka shū* (Collection of Japanese poetry of a thousand years, continued). Vol. 3, "Summer," no. 214/215. The fifteenth imperial poetry collection, completed 1320.

Shikishi 5

CALLIGRAPHER: Provisional Major Counselor Higashisono Motonaga (1675–1728). At court 1718–28.

WAKA AUTHOR: Sanjōnishi Sanetaka (1455–1537). Muromachi period courtier, poet, and scholar.

WAKA SOURCE: *Setsugyoku shū* (Collection of snow and jewels), no. 3671. Personal poetry collection of Sanjōnishi Sanetaka.

Shikishi 6

CALLIGRAPHER: Minister of Central Affairs Prince Fushimi Kuninaga (1676–1726).

WAKA AUTHOR: Minamoto Chikamoto (dates unknown).

WAKA SOURCE: *Fuboku waka shō* (Japanese selections of Japanese poetry), Vol. 9, "Summer III," no. 3434. Private collection compiled ca. 1310 by Fujiwara Nagakiyo.

Shikishi 7

CALLIGRAPHER: Middle Counselor Nishisanjō Kimifuku (1697–1745). At court 1718–45.

WAKA AUTHOR: Minamoto Masakane (1079–1143). Heian period poet.

WAKA SOURCE: *Senzai waka shū* (Collection of Japanese poetry of a thousand years), Vol. 4, "Autumn I," no. 251. The seventh imperial poetry collection, compiled in the late 12th c. by Fujiwara Shunzei.

Shikishi 8

CALLIGRAPHER: Middle Counselor Kasanoin Tsunemasa (1700–1771). At court 1712–71.

WAKA AUTHOR: Sanjō (Minamoto) Gyōsai, Ninnaji Temple Hōgen. Kamakura period priest and poet.

WAKA SOURCE: *Shin shūi waka shū* (New collection of gleanings of Japanese poetry), Vol. 5, "Autumn II," no. 522. The nineteenth imperial poetry collection, completed in 1364.

Shikishi 9

CALLIGRAPHER: Prince Arisugawa Bunnō (dates unknown).

WAKA AUTHOR: Fujiwara Tameie (1198–1275). Early Kamakura period poet and courtier. Son of Fujiwara Teika.

WAKA SOURCE: *Shin shūi waka shū* (New collection of gleanings of Japanese poetry), Vol. 5, "Autumn II," no. 535. The nineteenth imperial poetry collection, completed in 1364.

Shikishi 10

CALLIGRAPHER: Major Counselor Daigo Akitada (1679–1756). At court 1696–1756.

WAKA AUTHOR: Tamemichi (dates, surname unknown).

WAKA SOURCE: *Dairin gushō* (My foolish selections from the forest of poetic topics). "Autumn IV," no. 4777. Private collection, completed between 1447 and 1470. Attributed to Yamashina Tokio.

Tanzaku 1

CALLIGRAPHER: Prince Jisshinkei'in Gyōen of the First Order (1676–1718). Jisshinkei'in was his pseudonym. More often called Myōhōin.

WAKA AUTHOR: Retired Emperor Kazan (968–1008, reigned 984–986).

WAKA SOURCE: *Shin shūi waka shū* (New collection of gleanings of Japanese poetry), Vol. 1, "Spring I," no. 58. The nineteenth imperial poetry collection, completed in 1364.

Tanzaku 2

CALLIGRAPHER: Prince Arisugawa Yukihito of the Second Order (1656–1699).

WAKA AUTHOR: Priest Saigyô (1118–90). Late Heian period poet.

WAKA SOURCE: *Shin kokin waka shū* (New collection of ancient and modern Japanese poetry), Vol. 6, "Winter," no. 585. The eighth imperial poetry collection, completed in 1205.

The poem by Saigyō recorded in literary sources reads in Japanese as follows:
*Akishino ya / toyama no sato ya / **shiguru ran** / Ikoma no take ni / kumo no kakareru.*
 Saigyō's poem can be translated as:

> At that village nestled in the hills
> of Akishino, famed for autumn bamboo grass,
> **might the gentle rain be falling there,**
> where Mount Ikoma stands bedraped in clouds?

The third line of Saigyō's poem in bold above was changed by Prince Yukihito to **toki naran** when he brushed it.
 Saigyō's third line contains, before the grammatical suffix *"ran,"* three components in abbreviated writing that mean "gentle rain falling": the Chinese character for "time," the character for "rain," and the kana syllable *"ru."*
 Prince Yukihito's reading of the same line, on the other hand, contains the character for "time" (*toki*) and the syllable *na* before the same grammatical suffix *ran*, and means "Has the time for blossoms already come?"

Tanzaku 3

CALLIGRAPHER: Former Palace Minister Nakanoin Michimochi (1631–1710).

WAKA AUTHOR: Prince Nakatsukasa (dates unknown).

WAKA SOURCE: *Shoku kokin waka shū* (Collection of ancient and modern Japanese poetry, continued), Vol. 2, "Spring II," no. 170. The eleventh imperial poetry collection, completed in 1265.

Tanzaku 4

CALLIGRAPHER: Lord Reizei Tamehisa of the Third Rank (1686–1741).

WAKA AUTHOR: Kiyohara Motosuke (908–990). Mid-Heian period poet. Father of Sei Shōnagon. One of the Thirty-Six Poetic Sages, and compiler of the *Gosenshū*.

WAKA SOURCE: *Shūi waka shū* (Collection of gleanings of Japanese poetry), Vol. 5, "Congratulations," no. 277. The third imperial poetry collection, compiled in the tenth century.

Tanzaku 5

CALLIGRAPHER: Middle Counselor Sono Motoka (at court 1715–45).

WAKA AUTHOR: Ki no Tsurayuki (ca. 868–ca. 945). Heian period poet and courtier. Compiler of *Kokin waka shū*.

WAKA SOURCE: *Shin kokin waka shū* (New collection of ancient and modern Japanese poetry), Vol. 4, "Autumn I," no. 344. The eighth imperial poetry collection, completed in 1205.

Tanzaku 6

CALLIGRAPHER: Tonsured Prince Shōren'in Son'yū of the Second Order (1698–1747 or 1751)

WAKA AUTHOR: Kiyohara Motosuke (908–990). Mid-Heian period poet. Father of Sei Shōnagon. One of the Thirty-Six Poetic Sages, and compiler of the *Gosenshū*.

WAKA SOURCE: *Shin chokusen shū* (New imperially ordered collection of Japanese poetry), Vol. 7, "Congratulations," no. 476. The ninth imperial poetry collection, completed in 1235 by Fujiwara Teika.

Tanzaku 7

CALLIGRAPHER: Minister of Central Affairs Prince Fushimi Kuninaga (1676–1726).

WAKA AUTHOR: Unknown.

WAKA SOURCE: Unknown.

Tanzaku 8

CALLIGRAPHER: Consultant Shichijō Takatoyo (at court 1670–1686).

WAKA AUTHOR: Minister of the Left (identity unknown).

WAKA SOURCE: *Dairin gushō* (My foolish selections from the forest of poetic topics). "Winter II," no. 5977. Private collection, completed between 1447 and 1470. Attributed to Yamashina Tokio.

注

色紙（一）

<ruby>梶井<rt>かぢゐ</rt></ruby><ruby>一品<rt>いっぽん</rt></ruby><ruby>為仁<rt>ためひと</rt></ruby><ruby>法親王<rt>ほっしんのう</rt></ruby>筆（年代未詳）

　　誰里を　　かぜにうかれて　　たよりにも
　　あらぬそでまで　　におふむめがか

口語訳：誰の里だわからない程遠くから、風に乗って来て、頼り（便り）にならない
　　　　こんな私のところまで、匂ってくれる梅の香り、なんと芳しいことか。

出典：前参議飛鳥井雅有（1241–1301）『新続古今和歌集』巻第一春歌上#71

色紙（二）

<ruby>後水尾天皇<rt>ごみづのおてんのう</rt></ruby><ruby>皇女<rt>こうじょ</rt></ruby><ruby>級宮<rt>しなのみや</rt></ruby><ruby>常子内親王<rt>つねこないしんのう</rt></ruby>筆（1642–1702）

（三行目より左へ最後まで読み、それから最初の行を読む。散らし書き）
　　菫菜摘　　春の野原の　　ゆかりあれば
　　薄紫に　　袖や染劍

口語訳：すみれ摘みの行事には、春の野原での何か縁があるのでしょうか、私の
　　　　着物の袖は薄紫色に染まりました。

出典：土御門院（1195–1231）（在位1198–1210）八三代天皇　名：為仁（ためひ
　　　と）『題林愚抄』春部四#1385

色紙（三）

<ruby>花山院<rt>かさのいん</rt></ruby><ruby>前内大臣<rt>さきのないだいじん</rt></ruby><ruby>定誠卿<rt>さだまさきょう</rt></ruby>筆（1640–1704）（在官 1661–1692; 剃髪 1692）

　　みてのみや　　人にかたらむ　　桜ばな
　　手ごとに折て　　いえづとにせむ

口語訳：私たちだけがこうしてこんな見事な桜の花を見て、人には話すばかりで
　　　　良いでしょうか。てんでに折ってお土産にしましょう。

出典：そせい法し［素性法師］（平安初期）『古今和歌集』巻一春歌上#55

色紙（四）

<ruby>西洞院前大納言時成卿筆<rt>にしのとういんさきのだいなごんときなりきょう</rt></ruby>（1645–1724）（在官 1674–1724）

　　神まつる　　う月のはなも　咲にけり
　　やま時鳥　　ゆふがけてなけ

口語訳：神に捧げる卯の花も咲きました。山ほととぎすよ、夕方から宵にかけて
　　　　鳴いておくれ、夏の訪れを告げて。

出典：二条院讃岐（平安末期）『続千載和歌集』巻三夏歌#214/215

色紙（五）

<ruby>東園権大納言基長卿筆<rt>ひがしそのごんだいなごんもとながきょう</rt></ruby>（1675–1728）（在官 1718–1728）

　　夏がけて　　はなにさくとも　かきつばた
　　春のへだての　名にやのこらむ

口語訳：夏に渡って花を咲かせるけれども、かき（書き／垣）つばたよ、おまえは
　　　　春と夏を隔てる花として名は残るのでしょうよ。

出典：三条西実隆（1455–1537）『雪玉集』#3671 三条西実隆の家集

色紙（六）

<ruby>伏見中務卿邦永親王筆<rt>ふしみなかつかさきょうくにながしんのう</rt></ruby>（1676–1726）

　　まきしには　　おなじたねとぞ　見えしかど
　　千種にさける　　なでしこの花

口語訳：蒔いたときにはどれも皆同じように見えたのに、咲いて見たら、千種も有
　　　　るかと思うほど様々に咲いている、撫子の花よ。

出典：源親元朝臣（年代未詳）『夫木和歌抄』巻9夏部三#3434

色紙 (七)

西三條中納言公福卿筆 (1697–1745) (在官 1718–1745)

　をみなへし　なびくをみれば　秋かぜの
　吹くる末も　なつかしきかな

口語訳：女郎花が秋風になびいているのを見ると、どこから吹いて来るのかと懐
　　　かしく思えることよ。

出典：前中納言源雅兼 (1079–1143)『千載和歌集』巻四秋歌上#251

色紙 (八)

花山院中納言常雅卿筆 (1700–1771) (在官 1712–1771)

　うつしうへば　千世までにほへ　菊の花
　君が老せぬ　秋をかさねて

口語訳：移し植えたのですから、千代までも栄えて欲しい。菊の花よ。あなたが
　　　老いることなく、秋を重ねて永遠に薫り高くありますように。

出典：法眼行済 (鎌倉時代)『新拾遺和歌集』巻5秋歌下#522

色紙 (九)

有栖川文応宮筆 (年代未詳)

　敷嶋や　やまとにはあらぬ　くれないの
　色の千入に　染るもみぢ葉

口語訳：敷島の大和には見当たらない韓紅 (からくれない) に、千回も染め付けら
　　　れたような紅葉の葉よ。なんと鮮やかなことか。

出典：前大納言藤原為家 (1198–1275)『新拾遺和歌集』巻5秋歌下#535

色紙 (十)

醍醐大納言昭尹卿筆 (1679–1756) (在官 1696–1756)

　　秋しらぬ　まつとは見えず　露霜の
　　かゝる木末の　つたのもみぢば

口語訳：一見、秋の衰えを知らない松とは、とても見えない。露や霜のかかってい
　　　る梢には、蔦や紅葉の葉も絡まっているので。

出典：為道朝臣（年代未詳）蔦紅葉『題林愚抄』秋部四#4777

短冊（一）

じっしんけいいんいっぽんぎょうえんしんのう
實心繋院一品尭延親王筆（1676—1718）妙法院としての方がよく知られる。

　　香をだにも　あくことがたき　むめのはな
　　いかにせよとて　色のそふらむ

口語訳：香りだけでもあきることのない梅の花なのに、色までこう鮮やかなので
　　　は、いったい、どうせよというのでしょうか。

出典：花山院御製（968—1008）（在位 984—986）『新拾遺和歌集』巻1春歌上
　　　#58

短冊（二）

ありすがわにほんゆきひとしんのう
有栖川二品幸仁親王筆（1656—1699）

　　秋篠や　外山の里や　＊(1)時雨るらむ
　　　　　　　　　　　　 (2)時ならむ
　　いこまのたけに　雲のかゝれる

口語訳：＊(1)秋篠の外山の村里には雨が降っているのであろうか。その向こう
　　　の生駒岳には雲がかかっているから。

　　　(2)秋篠の外山の村里は、いや、本当にもうそんな時節なのであろうか。そ
　　　の向こうの生駒岳には、満開の桜が雲のようにかかっているから。

出典：＊(1)は西行法師（1118—1190）『新古今和歌集』巻六冬歌#585

　　　(2)は、桜を雲に見立てて詠んだと解釈できる和歌。出典は現時点では、
　　　どこにも見当たらない。短冊に書かれた字の墨付きが悪く判読しにくい。書
　　　家の幸仁親王が、わざと、古典を一捻りしたのか、単に間違えたのか未詳。

短冊（三）

中院前内大臣通茂卿筆（1631—1710）
なかのいんさきのないだいじんみちもちきょう

さきにけり　ぬれつゝおりし　藤のはな
いくかもあらぬ　はるをしらせて

口語訳：「あっ、咲いたな。」濡れながら手折ったこの藤の花は、そうだ、もう幾日
も残り少なになった春を告げているのだ。

出典：中務卿親王（年代未詳）『続古今和歌集』巻第二春歌下#170

短冊（四）

冷泉三位為久卿筆（1686—1741）
れいぜいさんみためひさきょう

君が代を　なにゝたとへむ　さゞれ石の
巌とならむ　程もあかねば

口語訳：貴方の御代を何に例えたらよいのでしょうか。細かい石が、大きな岩と
なる程、途方も無く永く続くことでしょう。

出典：清原元輔（908—990）『拾遺抄』巻第五賀#175（小野宮大臣の五十賀し侍
りける時の屏風に［詞書]）『拾遺和歌集』巻第五賀#277（清原公五十の賀し
侍りける時の屏風に［詞書]）

短冊（五）

園中納言基香卿筆（在官 1715-1745）
そのちゅうなごんもとかきょう

山がつの　かきほにさける　朝がほは
しのゝめならで　あふよしもなし

口語訳：山里の樵夫が住みそうな小屋の垣根に咲く朝顔は、夜明けでなくては会
うことができない。
きこり

出典：紀貫之（868頃—945頃）『新古今和歌集』巻第四秋歌上#344

短冊（六）

青蓮院二品尊祐法親王筆（1698–1751 又は1747）
<small>しょうれんいんにほんそんゆうほっしんのう</small>

> 我宿の　菊の白露　よろづ代の
> 秋のためしに　をきてこそみめ

口語訳：うちの庭先に咲いている菊にかかる白露が、（それは不老長寿を約束するということだから）、万世もの間皆が秋の習いとして経験しているように、どうぞ、私の家でもきらりと光りますように。

出典：清原元輔（908–990）『新勅撰和歌集』巻第七賀歌#476

短冊（七）

伏見中務卿邦永親王筆（1676–1726）
<small>ふしみなかつかさきょうくになががしんのう</small>

> もみぢ葉は　おりたく人の　心をや
> くみて千入の　色に見すらん

口語訳：このもみぢの葉は、あたかも折り焚く人の深い心を汲んで、千回も染めつけたような鮮やかな色になっているのだろうか。

出典：和歌作者不明。

短冊（八）

七條宰相隆豊卿筆（在官 1670–1686）
<small>しちじょうさいしょうたかとよきょう</small>

> 冬されば　さだかなりつる　ときは木も
> 又みえわかず　積るしら雪

口語訳：冬がやって来ると、いつもは、はっきりそれとわかる常緑樹も、まだ見分けがつかない。あんなに白い雪が積もってしまっているのでは…

出典：左大臣『題林愚抄』冬部下#5977